Orlando Crispe's
Flesh-Eater's Cookbook

David Madsen

Orlando Crispe's Flesh-Eater's Cookbook

Dedalus

Published in the UK by Dedalus Ltd, Langford Lodge, St Judith's Lane, Sawtry,
Cambs, PE17 5XE
email: DedalusLimited@compuserve.com

ISBN 1 873982 42 9

Dedalus is distributed in the United States by SCB Distributors, 15608 South New
Century Drive, Gardena, California 90248
email: info@scbdistributors.com web site: www.scbdistributors.com

Dedalus is distributed in Australia & New Zealand by Peribo Pty Ltd, 58 Beaumont
Road, Mount Kuring-gai, N.S.W. 2080
email: peribo@bigpond.com

Dedalus is distributed in Canada by Marginal Distribution, Unit 102, 277 George
Street North, Peterborough, Ontario, KJ9 3G9
email: marginal@marginalbook.com web site: www.marginal.com

Dedalus is distributed in Italy by Apeiron Editoria & Distribuzione, Localita Pantano,
00060 Sant'Oreste (Roma)
email: apeironeditori@hotmail.com

First published by Dedalus in 2000
Reprinted 2000
Copyright © David Madsen 2000

The right of David Madsen to be identified as the author of this work has been
asserted by him in accordance with the Copyright, Designs and Patents Act, 1988.

Typeset by RefineCatch Limited, Bungay, Suffolk
Printed in Finland by WS Bookwell

A C.I.P. listing for this book is available on request.

This book is dedicated to my dear friend

RORY PRICE

who is an arch-traditionalist in everything but food
and who kindly supplied Orlando Crispe with the recipe for
Vitello Arrosto dallo Spirito dell' Uomo Greco Antico

CONTENTS

PREFACE

It is only with a certain reluctance that I have been persuaded to offer this cookbook for publication. Some of the recipes it contains are from the very personal and particular repertoire of Maestro Orlando Crispe, whose confessions were made available to the public three years ago, shortly after his release from the *Regina Coeli* prison in Rome. Indeed, since that time he has not been allowed to set foot inside Italy, despite the recent death of Egbert Swayne, who committed the murder for which Maestro Crispe was first incarcerated. In vain did I try to point out that these recipes might well contain material of an incriminating nature; besides, I was convinced that the entire *Roman episode* and all material relating to it should be put behind him once and for all. However, Crispe can be an extremely persuasive man – especially with a kitchen knife in his hand – and he was determined that the fruits of his culinary expertise should be offered to the world.

He also took the extraordinary decision to put the Thursday Club on a much broader basis than it has hitherto been, opening it up to a wide range of individuals whose chief qualification for membership will be, we all fervently hope, a passion for the pleasures of flesh-eating rather than social distinction or financial substance. I am happy to say that I fully supported this decison, even though I think that because of it, the Executive Committee will have to be stringent in applying the new conditions to each individual case. Other members of the Committee were against it – in particular, Edward von Ströder and Cardinal de Santis – but they were outvoted by a majority of one. Von Ströder's objections were inevitable enough: he felt that by admitting a 'class of persons' other than those who presently constitute membership of the Thursday Club, standards would be lowered; Cardinal de

Santis was concerned that the Club's philosophical *raison d'être* would become diluted – a not untypical reaction from a Prince of an absolutist and dogmatic Church. Dame Vera Fisk was very much in favour of Maestro Crispe's decision, but there was no dissent when it came to voting on the maximum number of members the Club should be allowed to admit: five hundred, worldwide. Present membership has stood at exactly one hundred for several years. It is hoped that with an influx of new blood, the "flesh on the Club's bones will grow even healthier and more supple than it already is." Those are Maestro Crispe's own words. For myself, I feel that since we claim to live in an age of democracy – despite almost universal evidence to the contrary – we should try to behave like democrats. Several of the Committee Members have been kind enough to say what their own particular flesh-eating preferences are, and have allowed both Orlando Crispe and myself to provide a brief resumé of their – in most cases somewhat flamboyant – careers.

The recipes in this book have been carefully selected by Orlando Crispe, and they admit of no variation, since even the smallest detail – this is especially true of certain marinades – is the result of painstaking research and experimentation. The final result cannot be guaranteed without strict adherence to the instructions. Some of recipes have been taken from Maestro Crispe's published confessions, some are established classics, but there are at least three or four which have never been made public until now. This is also true of the narrative excerpts, several of which – for entirely personal reasons – were edited from the confessions shortly before publication, or have been taken from Crispe's unpublished diaries. I must also very emphatically state that Orlando Crispe is *sui generis* and therefore not a man to be imitated – indeed, it is crucial for many reasons, some of them obvious and some less so, that he should *not* be imitated. The recipes in this collection should be created with the meat specified: beef, lamb,

pork, veal, duck or chicken – you will, I am sure, take my meaning.

An application form for membership of the Thursday Club is included. If you have reasons for thinking that your application would be successful, please complete the form and send it to the publishers. It will be passed on to the Executive Committee in Geneva.

Orlando Crispe writes:
I understand Madsen's reluctance, but I do not share it. After all, what composer wants to see his compositions locked away in a drawer? What painter would be happy to have his paintings shut up in an attic? Genius, whilst always being true to itself and its own ineffable vision in which it is totally absorbed, nevertheless yearns to share the fruit of its ideation. The relationship between Madsen and myself has always been somewhat ambivalent and, to be perfectly honest with you, rather one-sided: he admires me, I find him useful in many ways; he likes to consume what I create, I tolerate his reservations concerning the precise method of their creation. This ambivalence is most clearly manifest in our opinion of the other members of the Thursday Club Executive Committee – he, for example, cannot abide Sir Arthur Stepney-Strange and considers him to be a professional fraud, whilst I am really rather fond of the old boy.

Madsen has also pointed out that some of the recipes in this limited collection are apparently nothing out of the ordinary – but in this he is quite wrong. What he fails to grasp is that in any culinary endeavour, it is above all the *weltanschauung* of the chef that matters, the fundamental *philosophy* underlying his art and the attention to every little detail which is designed to express this philosophy. Therefore, it matters not a jot whether the recipe in question is for *Côtes de Veau Maintenon* or Irish Stew – the genius perceives the vision, the vision engenders the philosophy and the philosophy inspires a creation of love, whatever the raw materials, however humble the means and method. The matter of music to accompany food is a case in point.

Music and food – or more particularly music and *flesh* – are

inextricably bound together in a deep and rich way; the relationship is symbiotic, for one affects the other and *feeds* on it, subtly transforming its effects on the human psyche. The art of cooking and the craft of musical composition share similar characteristics, the most significant of which is their non-rationality; this does not mean that they are *irrational* but, rather, that they cannot be explained in rational terms, for they transcend the utility of the operations of the intellect. They are, in the truest sense of the word, *mysticisms*. It is no coincidence that a high percentage of the great composers were addicted to one kind of food or another . . . or had very particular (not to say eccentric) culinary tastes . . . or were simply passionate about cooking. The 19th-century Sicilian composer Enrico Pappadardi for example, was utterly devoted to aubergines, and lived for many years on little more than aubergine pancakes; he claimed that there was something in the texture and the ripe, meaty flavour of this remarkable vegetable that inspired some of his finest melodies, which – like the aubergine itself – are essentially elegaic. Pappadardi is an extreme case of course, but the relationship between food and music, between chef and musician, is as intense now as it was in Pappadardi's time and indeed many centuries before that.

I have already explained that the different varieties of flesh have particular affinities to certain kind of music or musical instruments, which somehow seem to have the capacity to express their essence – or their *soul*, as I prefer to call it. The 'cello – and nearly all music written for the 'cello with the exception of ultra-modernist pieces – *sings* of pork, is the 'voice' of pork; beef is best represented by brass, especially the trumpet; on the other hand, lamb is definitely related to the flute, the harp and certain percussion instruments. I cannot conceive of anyone listening to Mozart while eating *Boeuf Stroganoff*. The advent of my synaesthesia, fully described in *Confessions of a Flesh-Eater*, allowed me to perceive these

14

fundamentally mystical connections and relationships, and to understand them; however, I am sure that it is perfectly possible for any sensitive individual to develop the same capacity, if not the same acute degree of it. I not only see flesh, I *hear* it. This gift – for it was not acquired by any effort on my part – has been of inestimable value to me in my creative work as a chef.

I further came to realise that it is not only the way in which flesh is cooked, but also the psychic vibrations within it, which will inevitably affect the one who consumes it – for better or worse. Once this astonishing fact is fully grasped, particular dishes may be created to have a precise and intended effect. This process has been described in detail in an account of my philosophy of Absorptionism which I have recently completed; the manuscript is presently in the hands of David Madsen, but I do not think he finds the ideas it sets out to his liking. Either that or they are unintelligible to him, which is far more likely. He has persuaded me to let him offer the manuscript to Knopf and Weil, the academic publishers based here in Geneva, but the advance they are currently offering is risible. Like every other genius, I am frequently at the mercy of profiteers.

My former ignorance about the matter of psychic vibrations did lead me to make one terrible mistake – I am referring to the nightmare that took place at *Il Bistro*, after which I was obliged to leave London in a hurry – but since that ghastly night, I have learned a great deal to make me wiser and more prudent. After all, we do learn by our mistakes. Now, here at *Le Piat d'Argent* in Geneva, I frequently put that wisdom and prudence to good use, creating very special dishes for customers with a very particular effect in mind – whether it be the fulfilment of unrequited love, the reconciliation of old enemies, the arousal of ardour (or the dampening of it, come to that), or the stimulation of sexual desire. Oh, the spectrum is infinite! With perfect

comprehension, perfect skill and the perfect combination of food, music and ambiance, there is no miracle that one cannot achieve. Why, I myself have achieved more culinary miracles than I can remember. The only other individual of my acquaintance who intuitively understands (almost) as much about psychic vibrations is Medlar Lucan, whose restaurant in Edinburgh I once visited; I find his obsession with decadence somewhat irritating, but it does at least mean that his creations are an expression of his own inward vision, which is what really matters. Lucan is not a genius however, even though his *Fin-de-Siècle Fritters* are quite scrumptious. Madsen does not share my opinion in this matter, but this is almost certainly because he despises Medlar Lucan; I would suggest that you visit Lucan's restaurant in Edinburgh and decide for yourself.

My own culinary philosophy, as readers of my confessions will know, is Absorptionism, and it behoves me now to state that the consumption of human flesh is the *sine qua non* of this philosophy — for it constitutes its logical apotheosis. Without Absorptionism, flesh-eating would be reduced to mere and horrid cannibalism; embedded at the heart of it however, it is elevated to a supremely creative act of love. *It is the destiny of the lesser to be absorbed by the greater.* When this process is presented as an art form, it gives glory to the Supreme Absorbent and is completely in accord with the warp and woof of the divine plan. It is in being faithful to this plan that knowledge of, and skill in the operation of psychic vibrations, is essential. But if Knopf and Weil see fit to raise the miserable advance they are presently offering, you may soon be able to read about all this for yourself. Madsen has always had certain reservations about both my raw material and my methods not only of obtaining it, but also of actually cooking it — I have already told you that I tolerate these. However, in my own defence — having been called a cannibal, a monster and an evil genius in my time! — I must say that whatever I have created for him (and on more than one occasion I have created a dish

according to his own somewhat peculiar specifications) he has inevitably consumed it with delight. It occurs to me that David Madsen's love of flesh-eating belongs to the world of his *Shadow* – as Dame Vera Fisk would undoubtedly call it. Personally, I would call it something else.

Meanwhile, I remain at *Le Piat d'Argent*, carrying on the labours of my chosen profession. Just as I did at the end of my confessions, I once again invite any of you who are passing through Geneva to sample my fare; and if there is some *special* dish that you require for a very particular occasion – or effect – be sure to let me know. I think I can promise that you will not be disappointed.

Orlando Crispe
Le Piat d'Argent
Geneva

THE EXECUTIVE COMMITTEE OF THE THURSDAY CLUB

PRESIDENT: ORLANDO CRISPE

CHAIRMAN: COUNT MENZIES McCRAMPTON

TREASURER: DR LEO KLEIN

Committee Members

EDWARD von STRÖDER

H.E. CARDINAL ANTONIO de SANTIS

DAME VERA FISK

PROFESSOR ARTHUR STEPNEY-STRANGE

UGO PATTINI

CANON RODERICK le PRICQUE

DAVID MADSEN

<u>LAMB</u>

Rosette of Lamb Stuffed with Olives and Almonds

Noisettes de Curé Aujourdoi

Noisettes à la Crème au Coeur de Passion

Tranche de Gigot Le Piat d'Argent

EDWARD von STRÖDER

Orland Crispe writes:
Eddie suffers from his reputation, as all men of originality do.
Look at me – a case in point. I don't think he knows anything
of the originality or otherwise of women, nor does he care to.
He once had a brief but passionate *affaire du coeur* with Her
Royal Highness the Princess Astrid de Bourbon Pradello-
Junkers, but it was a *coniunctio* of souls, rather than genitals, I
believe. Her Royal Highness (as far as Eddie is concerned)
betrayed their intimacy when she took up with Arno
Weinrich, the expressionist novelist, whose most recent *oeuvre*
is a publication of one hundred blank pages, which the reader
is invited to fill out for himself. Perhaps this is what turned
him against her species.

David Madsen 'accuses' him of being the *vox populi* of our
age; Eddie takes this as a compliment, but he also strenuously
resists it. Having read Madsen's potted biography of himself,
he said to me:

"In the name of heaven, is there anyone who has not
read Aristotle's *Rhetoric* or *Metaphysics*? Like most classical
philosophy, it is simply a matter of common sense. Which
would you rather look at: Caravaggio's *St Peter Martyred*, or a
monkey's brains pickled in formaldehyde? What would you
rather listen to: Bach's *B Minor Mass* or an hour of screeching
and grinding like Alexander Knippen's *Concerto for Typewriter
and Hosepipe?* The problem these days, is that people don't
have the courage to stand up and say what they feel – to state
the obvious, like the child in Hans Christian Anderson's story,
The Emperor's New Clothes."

Well, Eddie certainly does. He insists that sperm and dung
in painting, farting and mega-dissonance in music, blank pages
and endless obscenity in novel-writing is nothing more or less

23

than a superficial disguise of *a complete lack of talent*. As an individual of supreme talent myself, I agree with this whole-heartedly. Let us be honest: If you had no artistic talent, what better way to make your living in the world of art but to cut a pig into pieces and call it 'Paraphrase II'? Or take photographs of your own excrement and charge £3000 for them? If you were completely without any musical skill whatsoever, what swifter route to an interview with Melvin Bragg on Southbank than to write a symphony consisting entirely of intervals? We should make no mistake about it: these neanderthal rogues take us for idiots with more money than sense. It is precisely the same in the culinary world, as I certainly have cause to know.

Which is why Eddie adores me. He knows that I am a genius who does not have anything to do with the mask of novelty. I am not obliged to hide behind *avantgardism* for lack of true creative skill. When Eddie first tasted my *Noisettes d'Avignon* at *Le Piat d'Argent* five summers ago, he was overwhelmed. He told me then, and I tell you now, that his favourite meat is lamb. Admittedly, *Rosette of Lamb Stuffed with Olives and Almonds* was one of the courses served on that infamous night at *Il Bistro*, but Eddie has eaten it several times since at *Le Piat d'Argent* when there has been no untoward behaviour of any kind – either on my part or the other diners.

David Madsen writes:

Known to the small circle of his friends as 'Exquisite Eddie' and to the vast number of his detractors as 'the ultimate snob', Edward von Ströder, born in Berlin in 1956, is the youngest member of the Executive Committee of the Thursday Club but the one, perhaps, to whom most notoriety has attached. A year before he was elected to the Committee, von Ströder made tabloid headlines when he donned a pair of calfskin gloves before shaking hands with Princess Mafalda-Maria Grimaldi in Cannes.

"Historically speaking," he said, "there has never been any reason to regard minor royalty – or for that matter the Italians – as the most hygenic of people. Indeed, quite the contrary."

Edward von Ströder has devoted a great deal of his time and money to the arts, and is well-known for his anti-modernist views; he once bought a piece by Jason Stitch called *Paraphrase IV* – consisting of a freeze-dried pig's testicle in a glass box – for six thousand pounds, only to hurl it into the Thames from Hungerford Bridge two days later, in front of a crowd of thrilled journalists and photographers. Asked for his opinon of Stitch – whose favourite medium is animal genitalia – von Ströder said:

"The material is always expressive of the man."

Edward von Ströder is well-known for his pungent observations on the contemporary cultural scene; a book of epigrammatic pronouncements entitled *The Decline of Proportion*, in which he attacks the avant-garde in fine art, music and drama, was published last January by Fictus and Day, and has been in the top twenty best-selling non-fiction list ever since. Among the more unforgiving opinions voiced, we find:

"Those who prefer Stockhausen to Strauss are in need of a cerebral smear-test."

Edward von Ströder's palatial home in Geneva is graced with a fine collection of 16th and 17th century paintings, including two by the Dutch still-life master, Willem Kalf, on whom he is an acknowledged authority.

Inevitably von Ströder has made many enemies, yet there are some who regard him as the champion of the *vox populi;* von Ströder himself – perhaps the last person to consider that he might have anything at all to do with the common man – insists that he is neither a reactionary nor an entrenched traditionalist as many representatives of the common man by nature are, but, rather, a lover of skill, good taste and beauty.

"People don't need me to tell them when something is ugly or meaningless," he once wrote. "They know this instinctively – we all do. However, I've never been afraid to stand up and say it."

Edward von Ströder has long been a devoted admirer of the art of Orlando Crispe, and was invited to serve on the Executive Committee of the Thursday Club in 1991.

Rosette of Lamb Stuffed with Olives and Almonds

1 boned shoulder of lamb about 3-4 lb (1.35–1.8kg)
FOR THE STUFFING 4 oz (110g) fresh white breadcrumbs
1 tbsp olive oil
1 small onion peeled and chopped
10 stoned black olives
2 tbsp chopped almonds
2 cloves garlic peeled and crushed
2 sun-dried tomatoes, finely chopped
1 tsp mixed herbs

Preheat the oven to 220°C/425°F gas mark 7.

Blend all the stuffing ingredients and carefully place in the opened out shoulder. Fold the edges of the flesh over it, and secure with string in three places along the length. Arrange in a roasting tin and cook for 1½–2 hours, 30 minutes less for a more rare roast. Leave to rest for at least ten minutes before carving.

From *Confessions of a Flesh-Eater*

Everything had started so well and I had no reason to imagine that everything would not end well – indeed, I was already beginning to envisage the extravagant praise that would undoubtedly be heaped upon my culinary endeavours in the weekend newspapers and journals. Alas, it was not to be. It was about half-past ten, just as coffee was being served, that I began to sense something was wrong; it was an irritatingly elusive feeling, like catching a glimpse of something out of the corner of an eye, like being aware of another presence when you are certain that there is no-one else in the room. A vague unease, an uncomfortable premonition of something – but what? On the surface of things all seemed well: both the *Roast Loin with Peach and Kumquat Stuffing* and the *Rosette of Lamb Stuffed with Olives and Almonds* had been rapturously received; the conversation was flowing comfortably; the candles, low, cast the room and everyone in it in a lovely, mellow, opalescent glow pinpricked with *scintillae* of white light reflected on glass and silver . . . and yet – yet! – I knew that there was *something* amiss. Or shortly would be.

"Can you feel it?" I whispered to Jeanne.

"Yes. And I do not like it."

I closed my eyes for a moment and tried to make my mind receptive to its synaesthesic powers, but I quickly opened them again when the only image I saw was a human face twisted and distorted by a huge mouth, gaping wide and ready to scream.

"Neither do I," I said.

Just at that moment, as I was walking away from Jeanne, something – a swift, sly movement – caught my attention: the hand of a man was up to some mischief or other under cover

of the tablecloth. I moved a little closer. I knew the man in question – it was old Henry Futtock from *The London Towner* – and he was someone who, ever since he had written an appreciative comment about my *Trippa al Vino Bianco*, I had always regarded as slightly less disgusting than the rest of the critical ratpack.

"Everything to your satisfaction, Mr Futtock?" I asked politely.

He looked up at me with a cunning smile and said:

"Oh yes, yes indeed. I'm having a *frantic* time of it!"

He lifted the tablecloth and at once I saw what he intended me to see: the stiff, leathery prick protruded from the front of his trousers and he was rubbing it briskly with his right hand.

I leaned forward, placed my head close to his, and hissed in his ear:

"Put it away, for God's sake."

"Why should I?" he said with a giggle.

"You'll upset the others."

"Oh, I hardly think so."

Then he lifted the tablecloth a little further, and I saw to my amazement and dismay that Henry Futtock's prick wasn't in his *own* hand at all, but that of the man sitting beside him. In confusion I fled to Jacques, but it seemed that he had encountered a similar situation.

"Table seven – look –"

"Oh God. And table four –"

A low, throaty snigger came from a secluded corner some-where, followed by a brassy laugh. Then a tiny scream, only half-smothered, of shocked delight. At every table something was going on: fumblings, gropings, pinches and squeezes . . . snatched kisses, lingering kisses, kisses administered and received in unexpected places . . . fingers probing, eyes flutter-ing, thighs opening with experienced stealth, languorous and inviting.

Then, quite unexpectedly, someone flicked a spoonful of

chocolate soufflé across the room; it struck a fat, dowdy-looking woman full in the face, just below her left eye. She laughed in an absurdly coquettish manner and offered her cheek to her neighbour, who began scraping off the mousse with his tongue.

The chaos that ensured with unimaginable swiftness was indescribably shocking; it was so sudden and so violent, so obvious that it would be stopped only by burning itself out, that I was reduced to the status of a helpless onlooker, unable to stir, huddled in a corner like a frightened child. The twins, I noticed, bore a look on their faces that I can only describe as horrified bewilderment. Like me they stood motionless and passive. Tables, chairs, plates, food, *people* – everything and everybody in the room – was strewn about in anarchic disorder. It looked like the result of an act of uncreation. The sly, subtle whisperings over wineglasses and the even more sly explorations under tables had given way at first to mere boldness, then to hilarity, and finally to this orgiastic frenzy.

There was the noise: the noise was earsplitting – screaming, yelling, groaning, screeching, cries of vile pleasure and shouts of pain, hoots of triumph and moans of submission. The crack and splintering of wood as chairs shattered, the brittle singing of broken glass, the *whitchz!* of clothes ripped from bodies.

There was the smell – oh, the smell! It was the thick, miasmal odour of unrestrained animality, of a thousand and one illicit desires so long repressed by common sense and convention, now rising up from the lightless night-black depths of the psyche like malarial smog from a prediluvian swamp.

It was a cacophony that stank.

I saw two women squatting beside an upturned table; they had taken off their blouses and one was licking the nipples of the other, her head thrown back, her face contorted in a spasm of sexual agony.

A young man lay motionless on his back, his trousers down

31

around his ankles; someone had pulled his testicles out of his underpants and now they hung defenceless against the squeezing, rubbing, pummelling hands of those who crawled by.

Two men were fighting over the same woman; wearing only her panties she sprawled on the floor, her stomach streaked with bright blood. As they flailed and thrashed, I saw her hand go down between her legs, and she moaned lasciviously.

Several couples were actually having intercourse, either oblivious or uncaring of the people who were crouching and watching, whispering encouragement, suggesting techniques, touching themselves and each other in those private, vulnerable places that only embalmers and gynaecologists should know.

I saw one naked man mount another, crying words of love, of unashamed passion; then, as penetration was achieved and their hairy, overweight bodies began to pump in unison, I realised to my horror that one of them was Arturo Trogville. Moments later, I caught sight of the glitteringly vulgar companion he had brought with him: she was topless, writhing beneath a musclebound youth who had his mouth glued to one of her breasts and his hands underneath her buttocks. He lifted her body to meet his every manic thrust.

A single, full-throated roar ascended from the *canaille* and turned back upon itself to shatter, like a wave in a tempest breaking on the rocks of a hostile shore – a fearsome, bestial roar of insatiable appetite.

I heard the voice of Jacques in my ear, urgently sibilant:

"Let us leave before it is too late – *please* – "

Oh, God! What have I done? Look – that's Trogville over there, being well and truly buggered –"

"This is not passion – it is violence!"

It did not take long for that to become only too obvious: groans of desire and cries of satisfaction gave way to murder-

ous screams; mouths that had kissed and sucked now began to bite; caressing hands became vicious fists, and the bitter odours of fear and fury rose up from the tangle of undressed bodies.

"We must stop them, Jacques – they will kill one another!"

"But what can we do?"

"Oh, this is a nightmare!"

A half-naked woman came staggering towards us, her arms raised imploringly, her hands bloodied and torn; someone had thrust a dessert fork into her left breast – it dangled there shiny and absurd, like a long silver nipple.

"We have to get out of here," I said.

The woman collapsed at our feet; immediately, a merciless hand reached out and grabbed an ankle, dragging her back into the melée.

A voice screamed out above the din:

"What's happening to us?"

It was the voice of Arturo Trogville. He had managed to pull himself from beneath his partner in buggery and had staggered clumsily to his feet. Tears glittered at the corners of his wild eyes.

"He's crying," I hissed to Jacques.

"Why – look – they are *all* crying –"

Indeed they were. Sobbing, shuddering, wailing and shaking, they wept unrestrainedly, uncontrollably. Some had begun to cover their nakedness, brazenly denying complicity in either love or loathing; others screamed vile accusations; a few stood silent and ragged, their eyes full of incomprehension. The floor was slick with blood and semen.

Jacques placed his lips close to my ear and whispered:

"For God's sake – while there is still time –"

Time there was, but only *just*. Jacques, Jeanne and myself ran through the kitchen and made our escape through the side door – I locked it with my own key from outside, and as I withdrew it with a trembling hand from the lock, I heard the

mob begin to pound on the unpainted metal. It shook with the force of it. Had they apprehended us, they would have torn us to pieces.

Noisettes de Curé Aujourdoi

8 thick cutlets taken from the rib
1 glass good dry white wine
2 tbsp fresh coriander, chopped
½ pt (300 mls) chicken stock
3 oz (75g) unsalted butter
Black pepper

I first cooked and served this simple dish to His Eminence Giovanni Cardinal Pulcelli, who headed the Commission for Interfaith Reconciliation at the Vatican. The Curé Aujourdoi – an attractively muscular young cleric engaged in higher theological studies at the Gregorianum – was also very much present at the meal, but was unfortunately not in a position to appreciate its success.

Melt the butter in a deep pan and brown the cutlets over a high heat, turning once. Remove them from the pan and keep them warm. Deglaze the pan with the white wine, adding the coriander and a pinch of black pepper. Pour in the chicken stock and simmer for five minutes or so. Return to the pan and cook in the liquid until it thickens. Serve in a warm metal dish.

The Soul of Lamb

Lamb is everything fresh, clean and sparkling. It is meat of the morning sun, before the earth has become too hot beneath its later, fiercer rays; the joy of waking up on one's birthday before over-indulgence has promoted lethargy; it is the thrill of anticipation that characterises the five minutes before a performance begins, rather than the satiated despondency that lingers an hour after it has finished. Lamb is the sparkle of white gemstones, the cascade of clear apple-juice into a wafer-thin tumbler, spring sunlight dappling a lace curtain that billows gently in a sweet breeze.

The colour which best expresses the soul of lamb is green – chrome green in particular, but not the darker, more complex shades of viridian or olive, which properly belong to the world of pork. Imagine a translucent expanse of chrome green – perhaps nuanced by the merest hint of Naples yellow – shot through with the fragile lustre of silver. This is the colour of new life, new beginnings, fresh inspiration and uncluttered thoughts; in dreams, such a colour always betokens the passing away of what is old and stale, and the coming to birth of what is excitingly young and new.

Or imagine a spring landscape: gently rolling meadows and a crystal-clear brook rushing, tumbling over a pebbled bed; distant saplings reaching up to finger the pale blue morning sky; a faraway bird dipping and soaring for the sheer joy of it. The lamb surely wandered through the groves of the Eden garden before sin turned it into a desolate wasteland.

In art, lamb is best represented by lightness but surety of touch, by playfulness and spontaneity. It is the childlike delicacy of Fra Angelico, a sunny landcape by Caspar David Friedrich in one of his rare flights from melancholy (I am

thinking particularly of *Noon*, now in the Niedersächsisches Landesmuseum at Hanover), the lyrial Orphism of Chagall and the irresistible humour of Miró. Musically, Mozart has much of the lamb in him – this is particularly so in his chamber pieces for flute and harp – and I only have to listen to certain melodies by that divine genius for a few moments before I start dreaming of *gigot rôti*. The ecstatic dance of stringed arpeggios express the soul of lamb perfectly, but the piano can also sometimes do so with commendable accuracy – as, for example, the Rondo in E by John Field.

Lamb is the exultant vibrancy of adolescent sexuality, unburdened by guilt, in perfect harmony with the natural order, and completely unselfconscious. It is the joyous discovery of the pleasures of the flesh and light-hearted indulgence in these pleasures for no other sake than their own. It is blood pumping through firm young organs, ripe with swelling, rejoicing in release. It is the wide-eyed wonder of the first kiss, the unforgettable experience – marked by a commingling of pride and gratitude – of the first orgasm. Lamb, in short, is the meat of youth. It is flesh which dances.

Noisettes à la Crème au Coeur de Passion

1 small saddle of flesh boned and split into 2 loins and 2 fillets
1 clove of garlic peeled and crushed
5 fl oz (150 mls) double cream
5 tbsp vegetable oil
1 sprig fresh thyme
Freshly ground black pepper

Before preparing the noisettes, place the flesh in a large freezer bag. The cook should remove his clothing and position himself on his back on a comfortable bed, his head resting on a firm, supporting pillow. Music should then be played which will arouse feelings of a tenderly erotic nature – it is not the dark urgency of lust that is required here, but the gentle ache of gradual arousal. The choice of music will of course vary from individual to individual; to speak personally, I have always found that Rodrigo's *Concierto de Aranjuez* does the trick.

The freezer bag containing the flesh should then be placed over the genitals and resealed at the edges to form a snug fit. The bag needs to be fairly large (in most cases) since an erection is desirable; indeed, without it, the final dish will lack the pungency it should properly have. However, under no circumstances should the cook have an ejaculation. He then allows himself to doze off – at least two hours are required.

Upon awakening, the bag should be immediately removed from the genitals and the flesh set aside. The condensation which will have gathered in the bag should be very carefully collected and deposited in a small glass dish. Be patient – the more condensation collected, the better. Split the bag and garner the droplets with the blade of a knife if necessary.

Back in the kitchen, prepare the noisettes. Use a sharp knife to slice each loin into 6 noisettes, about 1¼ inches (3 cm) thick. Tie

the fillets in three or four places with string and cut into 4 slices. Set aside.

Mix together 2 tbsp of the oil, the crushed garlic, the thyme and the condensation previously collected from the freezer bag. Cook over a low heat, stirring continuously, for about 6 minutes. Add the cream, two tbsp of cold water, black pepper to season, and simmer gently for about 15 minutes, or until thickened to a sauce-like consistency. Remove the sprig of thyme.

Heat the remaining oil in a deep pan and add the flesh, browning thoroughly. Cook until medium-rare. Serve on warm plates and spoon the sauce over.

Tranche de Gigot Le Piat d'Argent

4 slices leg of lamb, 50oz (150 gm) each

6 cloves garlic coarsely chopped

2 sprigs of fresh rosemary

3 tbsp olive oil

I glass good dry white wine

Salt and black pepper

Heat the oil in a large heavy-bottomed frying-pan or a skillet, and sauté the garlic and rosemary until they are soft; this should take about 4–5 minutes. Remove and keep. Put the slices of lamb in the pan and brown on both sides for about 2–3 minutes, so that the flesh is quite rare. Then set them aside and keep them warm. Deglaze the pan with the white wine, return the garlic and rosemary, and stir gently until thickened. Arrange the lamb on warm plates and cover with the sauce.

From *The Unpublished Diaries of Orlando Crispe*
Wednesday March 21st, 19— —

That evening I knelt in front of my little shrine, raised my eyes
to heaven, and prayed as I had never prayed before – to my
beloved Highgate queen. Yes, that she still watched over me I
had not the slightest doubt; that her spiritual balm sweetened
the circumstances of my life to an extent I did not guess at –
how much more vexing might they otherwise have been! – I
was certain; and that she now heard my fervent prayer, I knew
in my heart.

"Mother and queen!" I said aloud, "why did you ever leave
me? Why did you die of sleep? Who dies of sleep? And yet I
will never believe the lies that the man who called himself my
father once told me – never! Look down upon me now, I
beseech you, look down in thy benign condescension and, as
it were, clasp me to your fragrant bosom as once you used to
do – oh, mother, oh – mummy!"

> *Queen of my life and light of my genius, have mercy on me,*
> *Inspiration of my art and source of my hope, have mercy!*
> *Mummy most pure, mummy most lovely,*
> *Mummy most beautiful, mummy most fair,*
> *Queen of all grace and bestower of blessings,*
> *My joy, my elation, my dream, my desire!*

Desire! Oh God, yes, I desired her still, as I always had, and now
it seemed that she came to me, my beloved Queen Mother,
descending as from some ethereal loftiness where the most
exalted of discarnate existents dwell – those whose higher
destiny does not as yet decree their ultimate disappearance
into the Divine Absorbent – a realm of unutterably exquisite

43

harmonies, of beneficent psychic vibrations, all healing, all peace, all wholeness. She filled my little bedroom with her radiance, moving in a sphere of golden light, her arms uplifted as if in benediction, her dear face smiling the effulgent smile of one who – having transcended the tribulations of this life – knows that in the end a safe harbour awaits every tempest-tossed barque.

It was then that I noticed she had no clothes on.

The natural assumption that beings of her spiritual stature do not require such things as clothes swiftly gave way to an upwelling of desire.

"Mummy!" I cried. "Oh! –"

Desire became a fiery hunger that churned my bowels and filled me with those urgent longings that only the twins had hitherto aroused in me; I felt the blood rush to my head and then, with a sickening force, plummet to my loins.

Queen of my life and light of my genius . . .

She enfolded me in her arms, my Highgate queen, and I was aware of her body (no doubt assumed for the occasion) pressing against mine – I noticed her breasts in particular, whose hard, hot nipples burned like needles against my chest. Her lips sought and found mine, and our tongues met.

Mummy most beautiful, mummy most fair . . .

She guided me with one shimmering hand, silently exhorting me to enter her, which I did, gliding slowly, purposefully home. She taught me to move in ways I had never known, to adopt postures I had never guessed at, baroque techniques that were shockingly, excitingly new.

My joy, my elation, my dream, my desire . . .

Just as she began to turn into a succulently dark, pungently slick shoulder of lamb, I lost consciousness.

<u>BEEF</u>

Manzo Gordiano dei Piaceri del Dolore

Meatloaf with Babylonian Boys Sauce

Entrecôte Bordelaise

Boeuf Stroganoff

Steak Tartare

Rissoles 'Il Giardino di Piaceri'

COUNT MENZIES McCRAMPTON

Orlando Crispe writes:

Beef has always been Menzies' favourite meat. He's an Australian by birth, and Australians love their meat. He once told me that for him, nothing can beat the deep, dark, rich taste of good beef, cooked and served rare, trickling with bloody juices. He salivates just at the thought of it. Long ago he acquired his own chef, since his busy lifestyle does not allow him to indulge his passion for cooking as he was once able to do; he still keeps abreast of culinary trends however and very occasionally it gives him great pleasure to prepare a dinner party for a dozen or so of his close friends. He doesn't like his food to be messed about with; please don't misunderstand this: Menzies expects imagination, flair, elegance and skill, but he can't abide *fancification*. To be frank, this is where my own genius reveals itself, because I manage to combine tradition with innovation, respect for the past with empathy for the future; I also know how to present a classically simple dish without feeling the need to apologise for it. I would a thousand times rather present a plate of good *manzo bollito* than goat's balls galettes on a bed of twice-fried mung-bean sprouts with passionfruit coulis, because I've lived long enough to know that the first would be the result of honesty, the second of the worst kind of culinary snobbism. Mind you, if I *did* do goat's balls galettes on a bed of twice-fried mung-bean sprouts with passionfruit coulis, it might be a different matter; I could even make you go for prawn cocktail, if I had a mind to.

Menzies did go in for fancification – just the once – and the media made him pay dearly for it for a long time afterwards. I am referring to the occasion when he served His Grace Archbishop Filiberto Bononcini with a little bit of

St Pellegrinata of Antioch in an omlette. The fact is, it was meant to be a *joke* between Menzies and His Grace – I know this, because he told me. It was a strictly private dinner party *à deux* and God knows how *The World Today* ever came to find out about it. I don't blame Menzies for holding that the media are a pain in the fundament. His late revered teacher, Maestro Bastini-Schwartz of the Hotel Gabriele d'Annunzio in Rome, once said to me: "Menzies is public property, *amico mio*. Let him make the fart, and the world will hold its nose." He was quite right.

Yes, Menzies is rich; yes, he's got homes all over the world; yes, he has what many would regard as an enviable lifestyle; and yes, he has been elevated to the ranks of the ecclesiastical aristocracy. However, he remains what he's always been – a down-to-earth Australian of good Presbyterian stock who loves his tucker and isn't ashamed to say so. You probably won't be surprised then, to learn that his favourite dish at *Le Piat d'Argent* is *Manzo Gordiano*. Actually, I call this *Manzo Gordiano dei Piaceri del Dolore*, but I can't be more specific about that; when Menzies first ate it one balmy summer's evening at *Le Piat d'Argent*, he assumed that it had been made with good Scottish beef. You must assume the same. I have been vilified during the past ten years by a lot of prurient, hypocritical *papparazzi*, as well as spending time in prison for a crime that I didn't commit. I don't think I want to add any further suffering to my quota. I would suggest that for this recipe, you use the best beef.

David Madsen writes:

Born in Brisbane of Scottish Presbyterian stock, Menzies McCrampton now regards himself as a 'global citizen', maintaining homes in Switzerland, Italy, New York and the West Indies. His highly successful chain of construction companies, inherited from his father, has ensured him a considerable personal fortune. He discovered his passion for flesh at an early age and was trained in the culinary arts by Vittorino Bastini-Schwartz of the Hotel Gabriele d'Annunzio in Rome; however, by his own admission, such training was undertaken not with a view to becoming a professional cook, but rather in order to educate and refine this passion. He converted to Roman Catholicism in 1957 and thereafter lived in Rome for many years – a city he still affectionately regards as his true spiritual home. In 1978 he was asked by Cardinal Jean-Louis Trifault to take over the reorganisation and management of all catering services within the Vatican, and five years later, in recognition of the labour he so generously lavished on this task at his own expense, he was created a Count of the Holy Roman Empire.

In the 1994 edition of *Monied Men* – the international *Who's Who* of multi-millionaires – Count McCrampton listed the two great obssessions of his life as 'my religion and my meat'; indeed, in very particular instances these two have coincided, as for instance the now notorious occasion when he served a high-ranking clerical guest at his Geneva home an omlette containing minute particles of dessicated flesh taken from a relic of St Pellegrinata of Antioch. This touch of gastronomic genius clearly reveals Count Menzies McCrampton for what he is: a devoted reactionary with an innovative imagination. He has always adhered to the old rites and rituals

of pre-conciliar Catholicism, and his personal chaplain cele-
brates daily a Tridentine Mass in the private chapel attached
to his villa on the Via Nomentana; this singular privilege was
accorded him by Pope Paul VI, with whom he was on
friendly terms.

Menzies McCrampton first encountered Orlando Crispe
in Rome, and became a regular customer at *Il Giardino di
Piaceri*. He applied for membership of the Thursday Club
soon after Orlando Crispe took over at *Le Piat d'Argent* and
was accepted immediately; in honour of his 50th Thursday
Club dinner, Maestro Crispe invited him to serve on the
Executive Committee. In 1990 Count McCrampton was
unanimously elected Chairman.

Manzo Gordiano dei Piaceri del Dolore

1¾lb (800g) of prime flesh taken from one who has expired of pain's pleasure, cut into 8 large chunks

4 fl oz (120mls) olive oil

2 shallots, finely chopped

FOR THE MARINADE
¾ bottle of good Chianti

2 tbsp red wine vinegar

1 onion, finely chopped

1 sprig of fresh thyme, fresh rosemary

I bay leaf

1 small piece of orange zest

Mix together all the ingredients for the marinade and steep the flesh in it for at least 24 hours. After this time, remove and drain it, together with the onion and herbs, retaining the liquid. Fry the flesh for a few moments on both sides in the olive oil. Add the shallots, the onions and herbs. Fry for a few more moments then transfer to an ovenproof casserole dish, covering with the marinade liquid. Cook in a low oven at 150° C/300° F, gas mark 2 for about 3½ hours. Serve with a robust red wine. I would suggest that the *Dies Irae* from Verdi's *Requiem* or from Berlioz's *Grande Messe des Morts* would be the ideal musical accompaniment; failing that, a Souza march or any piece arranged for a brass band. You should eat this dish naked; if you are a man, you should try to maintain an erection throughout, since it will, I assure you, immeasurably enhance the flavour. Women, naturally, will have to make their own arrangements.

From *Confessions of a Flesh-Eater*
He was naked except for his glossy leather boots. His pale, quite attractively muscular body glistened with a thin film of sweat. He knelt in front of me like a supplicant before an idol, his head bowed, his hands joined. At his insistence, I was clad only in my underpants.

"I've been so naughty," he said, his voice unnaturally high and schoolboyish.

"Why? What have you done?" I asked sternly. We had spent at least thirty minutes getting this tone exactly right – neither too awesome nor too pliant, the perfect blend of sympathetic understanding and unswerving rectitude.

"I've been so naughty. Oh please, please Daddy, don't punish me!"

"You know that I *must* punish you, if you have been naughty."

"Yes, I know. Daddy is always good but just."

"Fair but strict," I said, and I heard him utter a tiny orgasmic sigh.

"Oh yes, yes, fair but strict."

Then he took one of my hands and placed it on his left breast.

"Tweak me there," he urged in a parenthetical whisper, like an actor in a farce hissing an aside to the audience.

I grasped the hot little nipple, already stiff, between a forefinger and thumb, and squeezed, twisting it as hard as I could.

He cried out in pain.

"Oh, Daddy! Daddy is tweaking, twisting, pulling until it hurts!"

"How have you been naughty?" I boomed.

"Harder Daddy, oh, harder!"

"Tell me precisely how you've been a bad boy . . . "

"I've been naughty and wicked and *oh so bad*, Daddy –"

"Then you *shall* be punished."

"Punishment is terrible –"

"But good."

"Oh, but very good!"

"Very well, you know what all bad boys must do, don't you?"

"Please Daddy, please –"

"There's no use pleading, no use begging for mercy. You've been a bad boy, and for your own good you're going to suffer."

"Please, please, please, please!" cried the naked Otto von Streich-Schloss, who was clearly in paradise; as a matter of fact, I was quite beginning to enjoy my own role, but at present I do not care to speculate on the precise implications of this – I prefer to think that I was simply entering into the spirit of the game, and for a very worthy cause at that.

Herr Streich-Schloss turned on his knees to face away from me, leaned forward on his elbows, and thrust out his buttocks; they were pale, mottled with blue and hairy in a blond, downy sort of way.

"Daddy is going to punish you now," I said. "Daddy doesn't want to, but he must, because you've been a very bad boy."

"Yes, *very* bad," whimpered Herr Streich-Schloss.

"Daddy is going to smack you."

"Oh! Will it hurt?"

"Certainly it will hurt."

"Will it make me cry?"

"Without a doubt it will make you cry."

"Do I have to be punished now?"

"Indeed you do."

"With no clothes on?"

"Completely and totally nude. Not a stitch to cover you. All bad boys must take off every scrap of clothing to be punished. Daddy has to see *everything*."

Otto von Streich-Schloss' upside-down face peered at me beneath one armpit. He was grimacing and touching himself furtively between the legs.

In the absence of his stitched leather strap, he had selected from the kitchen a steel spatula with a thick wooden handle, which he thought most suitable for the job, and it was this instrument I now brought down on his left buttock with considerable force; the high-pitched, sharp, clean *zist-tttinngg!* sounded really rather loud in my small study, and the deep crimson weal, spreading like a blush, was perfectly discernible in the dying light of the early evening. I lifted the spatula high, thwacked him again, then again.

He was burbling, chortling, muttering to himself in a baby voice, growing more excited each time I struck his backside.

"Yes, yes, yes!" he crooned, "Daddy must punish me again, again – oh, yes – "

"Daddy is punishing his naked boy!"

All at once, I found myself quite involuntarily transported back to the scenario of my own childhood punishment – the one and only time my father had hit me, with that obsolete cricket bat. It was extraordinary how powerful, how *real* the resurrected memory was, played out now in my mind's eye in every little detail: I could smell the leather of the chair, feel the draught on the backs of my legs, hear my father's laboured breathing as he brought the bat down on my naked backside – and above all else, the sound of my beloved mother's nervous scream. I was caught, enmeshed like a fly in a sticky web, in that vivid time-trap. The harder and faster I struck Herr Streich-Schloss, the harder and faster my father seemed to strike me, even though in actuality his blows were feeble; the more shrill and panic-stricken his cries became, so did the screams of my Highgate Queen, although at the time I think

she had uttered only one. Like Proust's rusk, my steel spatula had become a technique of interior time-travel.

Then, once again aware of my father's crab-like hand moving at the back of my balls, in a likewise fashion I reached forward and grasped Herr Streich-Schloss' scrawny, dangling scrotum. I squeezed it gently.

"Oh yes," I muttered. *"A lovely pair . . . lovely . . . "*

Then I set about beating him with a furious energy, bringing the spatula down alternately on each buttock.

"You bad, bad boy, you wicked, monstrous child!" I screamed.

"Oh God, Daddy is punishing me – punish me hard, oh Daddy, oh *please* – "

"You unspeakable bastard, you filthy, despicable creature!"

"More, Daddy, *more* – harder, harder – Oh Daddy – oh yes, yes –"

At that moment I felt a light, warm spray on my face – it was blood. Herr Streich-Schloss had hauled himself upright on his knees, he breathing swift and shallow, his speckled shoulders heaving. Blood, claret-bright, ran down the backs of his legs. I saw that he was quiveringly erect.

"Oh Daddy!" he cried aloud. *"Now, yes, it's coming – oh! – now!"*

Before he was actually able to climax, I struck him hard across the side of his head with the wooden handle of the spatula, and he collapsed immediately.

As he did so, I thought:

Manzo Gordiano dei Piaceri del Dolore.

This meatloaf was presented to a small but active group of rather wealthy young men of excellent breeding, which calls itself *Babylonian Boys Inc.* It still meets once a month here at *Le Piat d'Argent* in Geneva and, I think I can claim without undue immodesty, always enjoys the dishes I serve – some of which are especially created for the occasion. Members of the group do not use their personal names, but each is known, with sincere affection, by *nom d'Amour*. However, I do not think I am giving away any secrets when I tell you that 'Cissie' is the thirty-year-old scion of an influential family of international bankers. On the evening of this particular dinner, *Babylonian Boys Inc.* had invited Edward von Ströder as their special guest.

Meatloaf with Babylonian Boys Sauce

1 lb (500g) very lean minced beef
8 oz (250g) very lean minced pork
3 oz (75g) freshly-made white breadcrumbs
I egg
I onion, finely chopped
I tbsp Worcestershire sauce
2 tbsp fresh coriander, chopped
Black pepper to season
FOR THE SAUCE 2 red peppers, deseeded and chopped
4 tbsp olive oil
1 clove garlic, roughly chopped
Pinch of cayenne pepper
1 tbsp freshly ejaculated sperm

Preheat the oven to 150° C/300° F, gas mark 2. Mix together all the ingredients for the meatloaf, and pour into a greased 2lb (1 kg) loaf tin. Press down firmly. Cover with foil and bake for about 2 hours. Then remove and allow to cool.

Put all the ingredients for the sauce into a blender and process until very smooth. Pour into a saucepan and heat over a moderate flame until hot but neither simmering nor boiling. Turn out and slice the cooled meatloaf and serve on warm plates, pouring the sauce over it.

The sperm should be freshly ejaculated, as specified; on the occasion referred to above, Edward von Ströder was invited by *Babylonian Boys Inc.* to be the donor, and he most willingly agreed. The member of the group known as 'Angelica' was, I believe, the equally willing agent. As a musical accompaniment to this dish, I would suggest Benjamin Britten's *Canticle 1: My Beloved is Mine*. Or, *faute de mieux*, something sentimental by Miss Judy Garland.

Entrecôte Bordelaise

4 steaks, trimmed, 8oz (225g) each
3 tbsp olive oil
Salt and black pepper
Sprig of fresh thyme
2 tbsp red wine vinegar
5fl oz (150 ml) beef stock
2 tsp coarsely ground black pepper
Pinch of cayenne pepper
1tbsp butter
3 oz (75g) shallots, finely chopped
4 garlic cloves, chopped
1 pt (600 mls) red wine
1 bay leaf
2-3 marrow bones
5 tbsp red wine vinegar

Rub the steaks with a little oil, season with salt and pepper, then cover and refrigerate for at least two hours. Remove them from the refrigerator about an hour before cooking.

Mix shallots, wine, garlic, bay leaf and thyme in a saucepan; boil for approximately 15 minutes, reducing by just over half. Strain. Discard the bay leaf and sprig of thyme. Wrap the marrow bones in cloth, place in a saucepan of water and bring to the boil, then simmer for ten minutes. Drain and remove the marrow jelly.

Heat a tablespoon of the oil in a pan, then when it is very hot, add the steaks. Cook for precisely two minutes on one side; season with salt and pepper, the cook for five minutes on the other side. The steaks must be pink within. Remove them from the pan, cover with half the shallot, wine and garlic mixture, then cover and set aside.

Into the still hot pan put the wine vinegar, boil for two minutes,

making sure to blend in all the juices; add the beef stock, the remaining half of the shallot, wine and garlic mixture, then the black pepper and cayenne pepper, and boil until reduced to about 10fl ozs (300 mls). Add the butter and stir well.

Heat what is left of the oil in a different pan and cook the steaks for approximately two minutes on each side. Spread the marrow jelly on top of the steaks and grill for just under a minute. Serve them on hot plates and spoon over the sauce.

The Soul of Beef

Beef bears me away to the world of primary colours – simple, strong, immediately intelligible; it is in some way, therefore, the foundation and first principle of my culinary alchemy, corresponding to the *nigredo* of the ancient alchemical process.

Picture, if you will, a vast virgin landscape: every form in it is simplicity itself, uncluttered and without complication, a world of clean black lines, smooth contours, configurations that lead to other configurations with clarity and precision. This is creation as it first emerged from the Creator's mind, as it first took shape in his mighty hand, and it is at once comprehensible. No-one has to ask: "What is this?" because everything is perfectly and completely itself, requiring no mediation. Red, white and black predominate, with splashes of secondary colour in between the spaces – like a painting by Fernand Léger, who happens to be an artist I greatly admire.

Beef is the calling and singing of bold brass – the horn, the tuba, trombone, saxophone, cornet, trumpet – never overpowering yet always firm, courageous; the more complex and subtle a beef dish is, the more other timbres are added to this basic sound – usually lower strings, but sharp sauces or condiments produce an overtone of shrill percussion. Beef Bourguignon, with a juice so rich it is almost black, is for me invariably associated with the tremendous passages for brass in the *Dies Irae* of Berlioz's *Grande Messe des Morts.*

Beef is the sexual potency of young men before it has been squandered; it is the pliant strength of newly developed muscles and the power of the erect male member; it is the

intensity and passion of fire, the warrior's prowess, the king's authority. It is, I am obliged to say – *pace* our contemporary sensibilities – a *masculine* meat.

Boeuf Stroganoff

2 ounces (50g) of butter
2 large onions, coarsely chopped
4 ounces (100g) mushrooms, sliced
½ ounce (15g) plain flour
1½lb (750g) fillet steak, cut into thick strips
1 tsp (5ml) mixed herbs
1 tbsp (15ml) tomato purée
2 tsp (10ml) French mustard
¼ pint (150ml) soured cream
½ pint (300ml) beef stock
salt and black pepper to season
chopped parsley to serve

Melt half the quantity of butter in a pan on a low heat and brown the onions. Turn up the heat, add the mushrooms, and fry for several minutes. Then remove from the pan and keep warm in a dish. Season the flour with salt and black pepper and toss the strips of steak in the flour so that they are well covered. Melt the remaining butter in the pan and quickly fry the steak until browned. Add to the dish with the mushrooms and onions. Stir in the beef stock, herbs, tomato purée and mustard, return to the pan and bring to the boil, stirring thoroughly. Pour in the soured cream. Heat without boiling, stirring all the time. Serve sprinkled with parsley.

This was the first proper meat dish I made, which my father with unforgiveable ignorance referred to as a 'stew'. It therefore has a very special place in my affections. Later, in Rome, I prepared it using the flesh of a sweet street boy; as a direct result of eating too much of it, Dr Herbert Bostrom, an aimiable old expatriate, expired on the eve of the publication of his magnum opus, *An Annotated History of the Doric Column.* His publishers have never forgiven me.

Steak Tartare

FOR EACH PERSON

¾lb (220g) of fresh fillet of beef or sirloin,
finely minced

1 egg yolk

½ tsp Worcester sauce

1 small onion, finely chopped

1 tbsp tomato ketchup

1 tbsp parsley, finely chopped

1 tbsp capers

1 tbsp extra virgin olive oil

Black pepper to season

Mix all the ingredients together in a deep bowl except the meat and the oil; use a wooden spoon for this. Add the olive oil, and when the mixture is thoroughly blended, add the meat. Take a handful of the blended mixture and shape it into a thin but firm round disk. Serve garnished with tomato and rocket.

Ideally, the flesh used in this recipe should be from a healthy, well-nourished, cared-for body. I usually prepare it using a basic ingredient to which others might not have access; if you can find a cow which is healthy, well-nourished and cared-for, you will not find yourself in the invidious legal position that I once did. *Buona fortuna.*

Rissoles *Il Giardino di Piaceri*

2lb (900g) fresh finely minced beef
2 oz (50g) fine white breadcrumbs
3 oz fine white breadcrumbs to coat rissoles
2 small onions peeled and chopped
3 tbsp strong beef stock
4 oz (100g) minced sausage meat
1 tbsp fresh chopped sweet basil
2 tbsp ruby port
1 tsp Hoi Sin sauce
Black pepper to season
Olive oil for frying

Mix all the ingredients together into a bowl except the breadcrumbs for coating, using the fingers to ensure that they are completely blended. Shape into 6–8 balls and flatten between the palms of the hands. Coat each rissole in breadcrumbs and fry in a shallow pan in the olive oil. Pat dry on a kitchen towel before serving.

From *Confessions of a Flesh-Eater*

We stripped Heinrich naked and laid him out on the great bed in the twins' room. He reminded me just a little of Master Egbert Swayne, who was of similar proportions. Henrich, however, had very little hair on his body, whereas Master Egbert had been positively cilicious – hair everywhere, except where he wanted it most, on his head.

It took some time to bring him round.

"Oh – where am I? – Orlando, my friend? Where *am* I?"

Jacques, also naked and looking rather beautiful, stood by the bed.

"I am your angel, Monsieur."

"My angel?"

Heinrich's eyes were already becoming ungummed and were beginning to feast themselves on the sight of Jacques' cool, glistening body. To be honest, I felt a little sorry for Jacques, but then – oh, then! – all true art requires its heros.

"I have come to minister to you, Monsieur."

"To minister to me? Ah – dear boy –"

Jacques passed one hand across Heinrich's right breast and paused to tweak the huge, thick, brown nipple.

Suddenly, he caught sight of me; I was standing in a corner of the room beside a massive candelabra that stood on the floor, supported by a base of engraved gold. God alone knows where *that* had been stolen from, and I didn't want to know.

"Orlando!" he cried. "Is this *your* doing? Could you not bear the thought that I must sleep alone?"

I smiled, but made no reply.

"Oh, Orlando!"

Jacques climbed onto the bed and covered – very

inadequately I must say – Heinrich's bloated body with his own.

"Watch us, Orlando," Heinrich murmured in a low, coarse voice. "Watch us do it – it will increase my pleasure – yes, watch while we do it – oh! – my angel –"

He pulled Jacques' mouth to his and began to move himself in an utterly nauseating way, imitating the nervous writhings of a virgin bride, his fingers fluttering coyly at Jacques' buttocks, his massive thighs shuddering.

"Love me, my angel – love me –"

I did not allow Jacques to suffer for long; as soon as Heinrich's eyes had closed and he began to moan, I approached the bed. Lifting his head with one hand, I removed a plump, silk pillow – he was quite oblivious of anyone or anything other than his own gratification. I nodded to Jacques, who raised himself slightly to one side. I placed the pillow with mathematical care over Heinrich's face and pressed down hard.

I heard a small, muffled groan.

"Press harder, Monsieur! Harder!"

I did so, for about half a minute.

"Harder! Why does he not struggle?"

"He's drunk, that's why."

I thought I heard another groan – fainter this time – but it could have been my imagination. Then Heinrich's arm fell over the side of the bed, fat and pale and limp.

"There. It is done."

Jacques sighed – with relief, I should imagine.

"Thank you Monsieur," he said.

Cutting up and disposing of Heinrich Hervé's massive corpse was not the difficult task I at first imagined it would be; in fact, in the end, it proved to be rather easy. Since both Heinrich's appearance and character were exceptionally pig-like, I followed the joint markings for that particular beast, using a Revlon *Sunset Glow* lipstick to cover his pale, bloated body with the bright red lines that would show me where I

had to cut. The two really weren't so very different – head, loin, chump, leg, belly, it was all there – except that I had to make do without the trotters, for even I blanched at the thought of Heinrich's severed hands and feet served up as *Pieds de Porc Grillé*, garnished with apple sauce and gherkins. I must make it clear, however, that I was using Heinrich as a substitute for *beef*, not pork, and apart from the sausagemeat, *beef* is the main ingredient in this dish.

The French have a saying to the effect that everything of the pig is good to eat – in English we say 'everything but the squeal'; certainly, it is a fact that more of the pig than any other beast provides *prima materia* for the most exquisite delicacies – the heart and the liver, it is true, are coarser than the heart and liver of lamb, but on the other hand, what else but the pig could provide us with fat so versatile it is wellnigh invaluable? The head is used to make brawn; the cheek cooked, shaped and breadcrumbed to make *Bath chaps;* the intestines are one of the chief ingredients of chitterlings; the liver makes delicious paté, and even the ears can be singed, simmered, breadcrumbed and fried. The main roasting joints are well-known to everyone: leg, loin, chump, belly, spare-rib, blade.

And all of these, Heinrich Hervé yielded up. As well as the hands and feet, I discarded also the heart (since I imagined this would be particularly tough), the liver and the tongue (the latter I was certain would be poisonous); there was no tripe to speak of, and of course no tail. In turning at least *some* of Heinrich into rissoles, I used a great deal of flesh from the shoulders, mincing it finely; it was, I suppose, the equivalent of ground pork, which is usually taken from the shoulder or forequarter. The kidneys I found to be particularly succulent – a fact I attributed to Heinrich's regular consumption of some of my finest wines; and, needless to say, there was absolutely *limitless* fat. Back fat I stored to use for wrapping around lean joints of pork or beef, and for turning into lard; the

transluscent crumbly fat around the kidney was superb for making pastry, just as it is in the pig itself. Oh, could I reasonably have asked for more? I think not. Dead and dismembered, Heinrich proved far more useful to me than he ever had when alive.

The genitals were surprisingly very small – a little curl of a cock nestling on its fat pouch. What an irony: the only thing about Heinrich he would have *loved* to be huge, was tiny.

"What did he do with that, I wonder?" Jacques said, wiping his bloody hands on his apron.

"Quite a lot, I believe. Thank God he didn't have time to do anything with you."

"My own sentiments exactly, Monsieur."

My rissoles *Il Giardino di Piaceri* were a sensation – just the kind of sensation, in fact, Heinrich himself would have adored.

<u>PORK</u>

Grillades de Porc au Chartreuse

Roast Loin with Peach and Kumquat Stuffing

Saupiquet du Barton-du Plessis

Pork with Mussels

Jambon le Piat d'Argent

ARTHUR STEPNEY-STRANGE

Orando Crispe writes:

I once knew a chartered surveyor who had to insert a pork
sausage into his rectum before he could become sufficiently
aroused to make love to his partner, a young Algerian waiter.
Oddly enough, this did not put me off pork, which remains
my own favourite meat; it did, however, put me off chartered
surveyors. This is something I have in common with my very
good friend, the well-known actress Miss Nola Noy – a love
of pork I mean, not a dislike of chartered surveyors.

I want to take this opportunity to state quite categorically
that Arthur did *not* invent the infamous 'F list'; this is a
rumour which has dogged his professional life for some years
now, and I am quite happy to offer this passing *apologia pro
labor suo*. Naturally, a highly successful person such as Arthur
atttracts enemies – especially from the ranks of those of his so-
called 'colleagues' who have not achieved his particular kind
of social – as opposed to professional – distinction. I know
what it is to have enemies, and my sympathies lie entirely with
my friend. That is all I have to say on this matter. Readers
might be interested to know that a second 'F list' is due to be
published next year by the Gabriel Academic Press, and they
will doubtless be relieved to learn that he hasn't made this one
up, either.

Perhaps his favourite dish on the menu at *Le Piat d'Argent* is
Grillades de Porc au Chartreuse. When I first recommended it to
him, I think he was convinced that the somewhat syrupy
flavour of Chartreuse would not go well with the already
sweetish taste of pork, but he was quite wrong. It is simply
delicious, and both he and I have consumed it with relish
many times since. It is quite commonly assumed (especially
since the publication of my confessions) that I always use

human flesh in the preparation of my astonishing dishes; well, all I can say is that this is not *entirely* true; sometimes I use plain, honest meat bought from a plain, honest butcher here in Geneva. I have my guests to think about, after all. Ugo Pattini is perhaps an exception, since it is a well-known fact that Italians will shoot, cook and eat anything that moves. Moreover, I would advise you to make a careful distinction between what I say, and what I actually do; I am by nature a highly imaginative person – that is, after all, what makes me such a superb chef. *Bon appetit!*

David Madsen writes:

I do not like Professor Arthur Stepney-Strange in the least, but I will try to be as objective as I can in this brief personal history. Professor Stepney-Strange has the dubious reputation of being the sexologists' sexologist; whether this honorific refers to his technical expertise or the success of his clinics in London and Geneva – where the discreetly powerful and the indiscreetly rich go to have their psychosexual difficulties relieved – it is hard to say. Certainly, Professor Stepney-Strange's academic qualifications are second to none, but it is also true that the facility with which he combines professional integrity and social glamour is the envy of the sexologist's – admittedly rather restricted – world. He spends most winters in Bermuda with Prince Alexis of Trœnheim-Schlessig, shares a luxuriously appointed private yacht with Miss Nola Noy the actress, and is the owner of a villa in the Languedoc where, according to his recent autobiography, Sir Michael Pennington lost his virginity to an unnamed American tennis star and, subsequently, lost his place in the Cabinet as a direct result. Yet Professor Stepney-Strange's penchant for the eccentricities of the *glitterati* has apparently not affected his reputation as a world expert in premature ejaculation in the slightest; he moves, like an amphibean, between the frothy clouds of social frivolity and the deep-sea depths of professional earnestness.

Arthur Stepney-Strange first shot to prominence a couple of decades ago with the publication of his report on the incidence of sexual fetishism in contemporary Britain; the sheer variety of fetishes he claimed to have uncovered – it became known, notoriously, as the 'F list' – was enough to guarantee him a permanent place in the history of sexology,

and his name was suddenly being mentioned in the same breath as the great Kinsey, and Masters and Johnson. Inevitably, Professor Stepney-Strange had his detractors, some of whom insisted that he had simply made the 'F list' up – and I confess to being one of that number. There were many even among his admirers who simply could not believe that there was a middle-aged housewife in Cambridgeshire who was sexually aroused by chopsticks, or a dentist in Manchester who experienced an erection every time a patient with halitosis breathed in his face – to say nothing of the young Suffolk policeman who had to suck his own unwashed socks before he could make love to his wife.

Professor Stepney-Strange has written many books, all of them accessible to the lay reader, of which perhaps the most critically acclaimed – and certainly the most widely read – is *The Case of the General's Chicken*. Two others – *Love for Her Ladyship* and *The Marshmallow Bed* - were translated onto celluloid as 'dramatic reconstructions' for West Anglian Television.

In 1987 Arthur Stepney-Strange was appointed Professor of Human Sciences at the University of Bucharest, and three years later accepted Orlando Crispe's invitation to serve on the Executive Committee of the Thursday Club.

Grillades de Porc au Chartreuse

4 slices of pork fillet
2 tbps clarified butter
1 tbsp extra-virgin olive oil
FOR THE SAUCE ¼ pint double cream
1½ tsp strong English mustard
2 shallots, finely chopped
1 tbsp white wine vinegar
2 tbsp green Chartreuse
Salt and black pepper to season

Fry the pork slices in the oil and clarified butter for a little over five minutes, turning occasionally. Season, then remove from the pan and keep warm.

Mix all the sauce ingredients together. Pour the fat out of the pan and put in the sauce mixture. Boil for 1½ minutes, stirring briskly and continuously. Arrange the meat on warm plates and spoon the sauce over.

From *The Unpublished Diaries of Orlando Crispe*
Sunday September 7th 19——

Despite the fact that she was in her early fifties, each of her breasts was like a ripe fruit: the flesh firm beneath the taut skin, hard and proud as it came to a point, and a little darker, tipped by a succulent bud where on the fruit there would have been a stalk, but on Gertrude' breasts there was an invitation to kiss, to suck, to squeeze. I did kiss those impertinent nipples, stiff as a man's aching member, and then I kissed her mouth again and again until she pleaded for breath.

"Orlando!" she cried. "For Chrissakes, don't kill me with your lips!"

"You are my honeybee," I whispered, taking each nipple between a thumb and forefinger, tweaking hard.

"Oh . . ."

"My plump and lovely honeybee."

I lay down beside her on the floor and slipped one hand up beneath her Galliano dress. The skin of her legs was smooth as cream, warm, yielding. I tugged at the elastic of her knickers.

"Where are you going?" she murmured, her eyes growing wide.

"You know well where I'm going."

"Your hand there – it gives me such strange feelings –"

"Good feelings?"

"Unthinkable feelings Orlando, unspeakable –"

"But good?"

"Oh, very good. Really quite delightful . . ."

The privities of a woman: a moist, hairy mound! Her actual opening, the succulent cleft of her, all plump and sleek! I placed my hand there and rotated it in a semi-circular motion, applying a mild pressure as I did so. She shifted the position of

her thighs very slightly, opening them a little, taking the weight of her body on her elbows.

"You're my honeybee," I murmured.

"And what are you going to do to me?"

"I am going to extract the honey from your sweet comb."

"God help me!"

"You have never yielded up your precious liquor before now?"

"Never, never."

"Out it will come," I said – thinking of what a sensational marinade it would make – "like juice from the fruit, stickiness from a spring bud."

I slowly pushed one finger up into her cleft, then, as she gasped and shuddered, another. I wiggled them inside her.

"Orlando, Orlando!"

"What?"

"If you don't stop, I'll die of pleasure –"

"But?" I said, inserting a third finger and, finally, a fourth.

"But if you do, I'll die of something much worse –"

"What?"

"Of disappointment. Of hunger and craving."

The tips of my fingers found the magical button deep inside her opening, covered over with its hot, wet layers of flesh exactly like a pearl within an oyster. I rubbed it and massaged it and was surprised by its hardness.

Gertrude began to shake all over, to tremble.

"How does it feel?"

"I can't describe it," she murmured. "It's incredible."

"Oh come on, try."

"Like a fire in my loins, like fire in every part of me, body and soul. Can't you see me shuddering and shaking? Something's coming, something that wants to drown me in itself – what? – oh, God! I'm like a circle that's getting smaller and smaller, and when I'm finally a single point, a nothingness, I'll explode and become a universe. I'm like a wave far out in the

ocean, gathering strength and speed as I roll onward, and when I reach the shore I'll crash and shatter into a foaming, roaring tide. Oh, Christ help me, oh – for pity's sake! – stop it, stop it!"

"Stop?"

"Never!"

Feeling her juice begin to flow, I removed my fingers. On an impulse, I lifted back her dress and gazed down between her legs; it was oozing out of her, thick as paste, clear as water. The lips of her cunt were pink, pink like coral, and swollen. I re-inserted my fingers and moved them rapidly up and down, burrowing and quarrying, like digging out preserve from a jar.

"Orlando! Oh no, Orlando, please don't!" she screamed, her hands flying to her breasts. A trickle of saliva snaked out of the corner of her open mouth.

"No?"

"Yes, yes –"

"Look, here it comes. Here it comes my dear Gertrude," I said. "Your honey. My little bee is making her honey."

"The world has become my hole!" she cried.

Her legs shook violently, banging noisily against the wooden floor. She gasped and groaned and uttered little whimpering sounds, like the grizzling of a small dog. She farted several times.

With trembling hands I held my cock, which was very stiff by now, and aching. I rolled on top of her and placed the tip of it against her sopping cleft. The cheeks of my arse were shuddering uncontrollably.

"Put it into me Orlando," she murmured, "and put me out of my misery . . ."

I *did* put her out of her misery, but not in the way she expected. I drew my knife from my pocket and passed it across her pudgey throat before she had time to even see it. She blinked once, then again, then her eyes closed forever. A gout of fresh, hot blood squirted up and struck me in the eye,

almost blinding me. And I thought: *What we artists have to endure*. Then a second thought came almost immediately: *Grillades de Porc au Chartreuse*. There was enough of her to serve six, at least.

Roast Loin with Peach and Kumquat Stuffing

1 loin of pork 3½ lb (1.6kg), bone removed
2 sprigs of sage
Stock or white wine for deglazing
FOR THE STUFFING 1 onion, peeled and sliced
6 fresh kumquats, unpeeled
2 peaches, de-skinned and stoned
3 oz (85g) fresh white breadcrumbs
1 clove garlic peeled and crushed
Salt and pepper to season

Trim the loin and discard excess fat. Chop the peaches and kumquats together with the onion. Add the breadcrumbs, garlic, salt and pepper seasoning, and mix well. With a sharp knife slit the loin of pork along its length and open it out flat. Spread the stuffing over the meat. Then roll it up and tie it at intervals, making sure that none of the stuffing comes out.

Preheat the oven to 180° C/350° F gas mark 4. In a deep non-stick frying pan fry the loin – without oil – until is is sticky and browned. Put the sprigs of sage in a greased roasting tin and place the loin on top. Roast for about 2 hours, until properly cooked.

Remove the loin from the oven and keep warm. Remove excess fat from the roasting tin and deglaze it with the stock or white wine. Boil and strain into a gravy boat. Pour over the loin before serving. Carve at the table.

Saupiquet du Barton-du Plessis

4 slices of ham carved thickly from the bone
4 tbsp melted butter
FOR THE BARTON-DU PLESSIS SAUCE 3 sprigs of fresh rosemary
1 small onion, chopped
1 glass of dry white wine
Black pepper
TO THICKEN SAUCE 2 egg yolks, beaten
1½ oz (50 g) butter
1 glass madeira
3 small mushrooms, finely chopped

Sauté the ham slices in the melted butter until slightly golden on both sides. Set aside and keep warm. Make the sauce by mixing the rosemary, onion, wine and pepper; then remove the rosemary and thickening the sauce by adding the beaten egg yolks and the butter. Lastly, add the madeira and the chopped mushrooms. Simmer for a few minutes.

Serve the meat on hot plates and pour the sauce over it liberally.

I first created this dish using the flesh of a young lady of my acquaintance called – unsurprisingly – Arabella Barton-de Plessis. She was delicious in every sense of the word. I advise you to use ham, when preparing it.

The Soul of Pork

Pork belongs to the world of secondary colours – of muted, autumnal shades and the darker blends of russets, ochres and olives; whereas beef is the offspring of the sun, pork is of the moon – a twilight domain of mystery, imagination, the subtleties of contemplative moods, of the reflection of an image in the mirror, rather than the original which casts it. Because the soul of pork is secondary rather than primary, an effect rather than a cause, it corresponds to the *albedo* of the alchemical process. Furthermore, pork is symbolic of the doorway which leads through death, and there is in its character something of decline, decay and the succulent richness of whatever is over-ripe, decadent, prolonged beyond the span of its natural cycle.

Imagine a terrain of complex, evasive shapes, forms that are capable of sudden self-mutation – changing perspective and shifting position – so that one is not quite sure whether they are houses, trees, haystacks or rocks; then paint such a terrain with a palette of subtle secondary colours, adding a touch of lunar silver here, a streak of earthy bronze there, until it seems that one moves within the dimensions of a dream. The world of dreams is significant here, for on the cabbalistic Tree of Life, pork is to be located in the sephira of Yesod – the sphere of all dreams, of the underworld, of the rituals of night and the initiations of the imagination. It is a melancholy landscape, yet one that is both addictive and seductive – a place which, once entered, holds the psyche in thrall.

Many of the mysteries of pork are echoed in the paintings of the symbolist school – I am thinking in particular of artists such as Gustave Doré, George Frederick Watts and Fernand Knopff. The French symbolist Odilon Redon was also very

much a 'pork painter' with his exquisite pastels of secondary hues and his often *outré* subject matter; he very much belongs to the world of dreams. Musically speaking, pork possesses the deep-toned *tristesse* of the 'cello – I am of the opinion that Saint-Saëns' piece *The Swan* from his *Carnival of the Animals* should rightly be called *The Roasted Pig*, so accurately does it capture the temperament and personality of this particular variety of flesh, but I have not as yet come across any other culinary artist who shares my opinion – or anyone who actually understands it, to be frank. The way of the genius was ever a solitary one! Another example of 'pork music' that springs to mind is the *Adagietto* from Mahler's fifth symphony.

The soul of pork resonates most harmoniously to the psychic vibrations of lesbian love; I do not know why this should be so, but I assure you that it is. Whenever I smell pork flesh cooking, the same image always flashes into my mind: two young women writhing together on a rumpled bed, their sweat-dewed limbs entangled, making passionate love by moonlight; they are naked, and one has mounted the other, hairy mounds pressing close, nipples quiveringly erect, lips scarlet and swollen with desire-maddened kisses. A chaotic panoply of love's accoutrements litters the sour-smelling room: devices to prolong ecstasy, to retard the divine moment of the little death, equipment to administer mild pain, creams and lubricants and rubber implements slick with glistening fluids. One of the women arches her back, bucking and thrashing, and she screams; then the vision is gone, and I am left only with the fragrance of the cooked meat.

Pork with Mussels

1½ lb (680gm) diced pork flesh
1 tbsp olive oil
1 onion, finely chopped
2 cloves of garlic, finely chopped
Handful of fresh, shredded coriander
¼ pint of chicken stock
1 glass of dry white wine
Salt and black pepper to taste

Rinse the mussels thoroughly. Brown the pork in the olive oil then add the onion and garlic. Fry for a minute or two more. Add half of the stock and all of the wine. Bring slowly to the boil, then cover and simmer until the pork is tender. Turn up the heat and add the mussels. Cover again. After 2 or 3 minutes add salt and black pepper to season. Last of all, put in the shredded coriander. Cook for a further few moments, then serve at once.

I have found – since this dish is essentially Portuguese in inspiration – that the tender flesh of a Latin lass works wonderfully well; if she happens also to be a lesbian, so much the better, for lesbianism, as I have pointed out, belongs to the soul of pork.

From *The Unpublished Diaries of Orlando Crispe*
Friday 1st August 19——
The nightmares I am having now began at the time of which I presently write as dreams – strange, confusing dreams it is true, but quite definitely not the dark, hideous webs of entangling horrors that the Italians call *incubi*. Not them, not then, at any rate.

Once, I dreamed I was walking through the streets of Rome.

The scene in which I found myself possessed the fluid, unpredictable surrealism typical of a dream: a dreamscape's spatial and temporal arbitrariness enveloped me, dissolving the solidity of stone – the crumbling stucco of alleyway walls, the knotty cobbles beneath my feet – and the familiar substantialities of the night – voices echoing behind, shuttered windows, the susurration of distant fountains, the muted rumble of ceaseless traffic – transmuting them into an aqueous gauze, like the backdrop of a stage, so that I no longer knew whether I moved in, through or beyond it. I did not know, and I did not greatly care, for I was content to drift through the city, sniffing the air like a nervous, expectant dog, with ears pricked and haunches aquiver. Neither could I tell whether I was observed or even observable in this disaligned state, for no-one acknowledged my passing or impeded my way through the gaggles of slick, olive-faced youths who stood preening themselves in shop windows, the café tables spilling out onto the pavement, the stick-thin Ethiopians hawking their gaudy wares from the bonnets of cars. Perhaps I was like a shadow – there but intangible, real yet lacking a third dimension; then again, perhaps I appeared to be exactly what I actually was,

the alteration being in my own faculties of perception. I could not tell.

Much else was familiar to me, such as the constitution of Rome's nocturnal homage to Venus: a woman glimpsed through an open window, sprawled asleep on a rumpled bed, her skirt dragged up above the waist to expose the fat, hair-darkened pubic mound . . . a couple pressed into the darkness of a ravaged portico, engaged in sexual intercourse where they stood . . . a young mother, ripe as a peach, sitting on the steps of her apartment building and holding an infant to one great, bursting breast . . . lovers raising their glasses in the flowery courtyard of a backstreet *trattoria* . . . an elderly white-haired gentleman with the profile of a Caesar sitting alone, lost in the enchanted byways of memory . . . and then, finally, a young man sitting on the outer rim of a baroque fountain.

His eyes, dark beneath the darker brow, stared unblinkingly into the middle-distance; he was wearing denim shorts and his sturdy, hairy legs were drawn up, knees to chest, his bare feet clinging to the pock-marked *travertino* stone. Behind him the water, iridescent in the moonlight, pinpricked the silence of the deserted *piazza* with its shy tintinnabulation. The young man slipped a hand down into the humid depths of his crotch and caressed himself with a unselfconscious tenderness. He sighed.

Then, quite unexpectedly, he looked up at me and said:

"You are the incarnation of a leg of pork."

A leg of pork? An incarnation of one of the great, long-dead masters of culinary alchemy I could understand – or even minor one, returned to this earth to perfect the skills left unperfected at death – but a leg of pork? It was vaguely insulting, surely . . .

He lifted himself from the rim of the fountain and walked slowly towards me, benign and smiling, handsome as only young Italian men can be. His dark eyes sparkled. He began to unzip his trousers. Then, when our bodies were almost

touching and I could feel the heat of his breath on my face, he pulled his great, fat cock out and laid it gently on the palm of my hand, but when I looked down it wasn't a cock at all, it was a pork chop – a pinkly glistening chump chop. I drew back in revulsion.

"What's the matter?" he said, speaking in English now. *"Don't you like my flesh?"*

And when I looked up again, he had the face of a pig. The glistening snout quivered.

"Eat me!" the pig-boy commanded. *"Eat me!"*

And I woke cold, cold and shivering in my bed, even though the night was seasonably warm.

Jambon Le Piat d'Argent

Thick ham slices cut from the bone, one per person
1 onion, finely chopped
7 oz (200g) sausagemeat
4 tbsp butter
I egg, beaten
3½ oz (100g) dried, chopped apricots
3½ oz (100g) sultanas
2 cooking apples, peeled and diced
2 tbsp cognac
7 oz (200g) puff pastry

Preheat the oven to 190° C/375°F, gas mark 6.

Melt the butter in a pan and sauté the onions until they are lightly golden but not brown. Add the sausagemeat, apricots, sultanas and apples. Mix together thoroughly, then simmer for 15-20 minutes on a low heat.

Grease a round ovenproof pie-dish and spread half of the mixture across the bottom of the dish. Lay the slices of ham on top and spread the remaining mixture over them. Roll out the puff pastry and cover the contents of the dish with it, trimming the edges. Glaze with the beaten egg and make a small hole in the centre with a knife. Put into the oven and cook for about 15 minutes. After this, remove and pour the cognac through the hole in the pastry. Replace in the oven and cook for a further 15 minutes, lowering the heat slightly. Serve when golden brown.

My very good friend Canon Roderick le Pricque tells me that this is his favourite supper dish.

CANON RODERICK le PRICQUE

Orlando Crispe writes:
Like me, Roderick le Pricque is an outsider; unlike me
however, he is in this position of mixed blessings not because
he is a genius, but on account of his incorrigible dilettantism.
Although I consider le Pricque to be a good friend, this is
something of which I myself could never approve; my whole
life can be summed up by the single word *dedication* – which is
precisely the opposite of dilettantism. I would therefore rather
leave it to Madsen to provide you with details of Canon le
Pricque's chequered career; suffice it to say that he is a
devotée of my culinary art, and this is the only thing that
matters to me.

David Madsen writes:

Canon Roderick le Pricque is a well-known and much loved figure at *Le Piat d'Argent*. His ample form is often to be seen seated at his favourite private table overlooking the serene expanse of Lake Geneva, tucking into a plate of *Tagliatelle con Fungi Porcini* - washing it down with a glass of *Barolo Vigneto Boscareto, Batasiolo 1988* - and of all the Executive Committee Members, Canon le Pricque is the one who most frequently dines in Maestro Crispe's restaurant.

He was born in Auckland, New Zealand, and raised as a devout Methodist; however, at the age of eighteen he converted to Anglicanism and studied for the priesthod in Beirut. After ordination he was sent to Israel for further studies in Hebrew and Apocalyptic Literature, and whilst living there became a noted *intîme* of the Latin Patriarch of Jerusalem. They were often to be seen dining out together at small, unpretentious family-run hostleries, engaged in fierce theological debates which became increasingly arch as further quantities of alcohol were consumed. Canon le Pricque made it clear that he was very sorry to have to leave Jerusalem and return to his native country for rather more mundane pastoral work.

Back in Auckland, he quickly acquired the reputation as a *bon viveur*, and was much sought after as a dinner party guest; this did not endear him to his Bishop, the Right Reverend Archibald Price, who was of the considered opinion that pastors should be pastors, and not socially ambitious members of the *glitterati*. The fact that Canon le Pricque was known as 'Mabel' among his media-worthy friends and acquaintances, did not help matters. Eventually there was an unpleasant confrontation, during which Bishop Price excluded le Pricque

from his diocese, and the Canon was obliged to return to Jerusalem where he was ordained as an Old English Catholic priest by Cyril Willthorpe, the self-styled 'Archbishop of the Old English Empire and All the Islands Church'. Willthorpe – a retired bookseller from Hull and a lifelong batchelor like le Pricque himself – commissioned the Canon to take charge of the small Old English Catholic community in Malta, where he still has a large villa and a tiny private chapel, in which he celebrates Mass in the Sarum rite, much beloved by Old English Catholics. Canon le Pricque was excommunicated by Bishop Price eight years ago, although he continues to maintain what he calls "an amused but affectionate regard" for the Anglican Communion.

Canon le Pricque is an inveterate traveller, and every winter spends six weeks in Tangiers, where it is his habit to minister to the English expatriate residents. There, he is well known for his weekly dinner parties, to which only the most eccentric and outrageous of the expatriates are invited; five years ago the periodical *Englishmen Abroad* printed an account of the now notorious occasion when le Pricque, his houseboy Ali and three friends attired themselves as nuns and danced on the beach at midnight, drinking champagne and reciting the poems of Walt Whitman through loudspeakers. It was in Tangiers that he researched and wrote his *Episcopi Vagranti* – an erudite and spirited defence of the so-called 'wandering bishops' of the many and various independent churches claiming apostolic succession; however, le Pricque offended Cyril Willthorpe by not including him in the book, and Willthorpe duly excommunicated him six weeks after publication. Gin and tonic in hand, Le Pricque himself observed insouciantly:

"My dear, I've been excommunicated so many times, I've lost count. I *did* include Willthorpe in the book – he was a footnote on page thirty-seven. The silly little bitch probably didn't even read it, anyway."

Undeterred, he continued – and still does to this day – ministering to his little flock both in Malta and in Auckland, to where he periodically returns, much to the chagrin of the ageing Bishop Price.

In the summer of 1993, in Geneva to address a conference of the Association of Independent Catholic Churches, Canon le Pricque dined at *Le Piat d'Argent* and was introduced to Orlando Crispe. They became friends in a very short time, and a year later Maestro Crispe invited him to fill the vacancy on the Executive Committee caused by the death of General Sir Arthur Bottoms, the renowned explorer. It was for le Pricque that Orlando Crispe created his *Vitello Arrosto dallo Spirito dell' Uomo Greco Antico.*

Vitello Arrosto dallo Spirito dell' Uomo Greco Antico

2lbs (900g) boned, chopped middle neck of veal
3½ oz (100g) lean chopped smoked bacon
3oz (85g) *funghi porcini*
¼pt (5 fl oz) single cream
½ oz (15g) unsalted butter
2 oz (55g) pitted Greek olives
I tblsp plain flour
½pt (10 fl oz) chicken stock
2 tsps fresh male perspiration gathered after physical exertion

A word of explanation, first, about the fresh male perspiration: it should be scraped from the flesh of a man in his mid-twenties, and should be the result of a bout of prolonged physical exercise – this is crucial, since it must be really fresh. Stale perspiration will produce a sour-sweet aftertaste and will almost certainly induce a mood of melancholy in whoever consumes the dish. The particular kind of physical exercise is left to the discretion of the chef; it can of course be sexual, but for a perfect *Vitello Arrosto dallo Spirito dell' Uomo Greco Antico*, it must be homosexual. The reason for this is obvious. I myself infinitely prefer some variety of athletic exertion performed in the nude; in any case, the ancient Greeks were adepts at both male love *and* athletics. Ideally, the perspiration should be taken from under the arms, the lower belly and the scrotum.

Spread one teaspoon of the fresh perspiration over the veal and leave to marinate for two hours.

After marination is complete, lightly flour the meat and sautée it in the butter, together with the chopped, smoked bacon. Seal and very lightly brown. Turn off the heat, then add the cream, white wine and chicken stock. Stir thoroughly.

Transfer the contents of the pan to a large casserole dish. Add the mushrooms, olives and the second teaspoon of perspiration. Cook in the oven on a low-to-moderate heat for 1½ hours.

As a musical accompaniment to this dish, I would suggest René Homer-Clare's *Impossibilities on the Greek Islands* or excerpts from Stravinsky's *Oedipus Rex*. On no account be tempted to listen to *The White Rose of Athens* – only one who neither understands nor is in any way serious about psychic vibrations would succumb to that.

From *The Unpublished Diaries of Orlando Crispe*

"Another gin please, dear!" cried Canon le Pricque, waving his empty glass in the air. It was immediately taken away and refilled by Ali, his houseboy. The Canon laid one pale, plump hand across the impressive expanse of his belly, fingering the little jet buttons of his Gamarelli clerical cassock.

He looked at me benignly.

"I'm so glad you could come, Orlando," he said. "You've been promising for simply ages. What did you think of our little performance this morning?"

He was referring to the High Mass he had celebrated in the private chapel of his villa, at which I had been a member of the small congregation. I suspect that he had introduced one or two decidedly flamboyant liturgical novelties of his own devising, in order to impress me. Without waiting for me to reply, he went on:

"The Sarum Rite has always been a special favourite of mine as you know. It's pedigree is by far the most lustrous in my opinion, although I dare say that Madsen would disagree."

"Cooking is my religion" I said, "and the kitchen is my temple. Besides, I live in Geneva – Malta seems a long way to come for High Mass."

"Ah, the kitchen!" he cried, slurping at his gin. "There, Maestro, you perform a quite different kind of transubstantiation. But I hope I may have one or two surprises up my sleeve even for you, my dear. Ali will have lunch ready for us shortly."

He pronounced the word 'lunch' as a kind of sybaritic benediction, rolling the sound of it around his tongue, releasing it from his clenched teeth in an attentuated hiss: *lllunnncchhhhh*

"Naturally, you must expect the theme of the meal to be North African. But I do not think you will be disappointed."

I certainly hoped not. Although I was fond of le Pricque and was pleased to see him again, the lunch I had been promised was one of only two real reasons why I had made the tedious journey to Malta; the other was his signature, which I needed on the new charter for the Thursday Club, abolishing several of the restrictive clauses it had hitherto included and putting membership on a much broader basis. I knew that I would get the signature, but I also knew that I would have to endure several hours of ecclesiastical gossip before I did.

As it happens the lunch was good, and I began to feel a little less like a captive audience after the *Lamb Tagine with Coriander and Parsley* accompanied by *Pumpkin and Aubergine Kebabs* served on a bed of cinnamon-flavoured rice. There was also *Prawns with Coconut* and a powerful *Lobster Piri Piri*, which I had thought was a Nigerian speciality, far removed from the somewhat dusty, herbal flavours of North Africa. However, I said nothing. We finished with peeled, chopped oranges and melons smothered in a vodka and vanilla sauce. Canon le Pricque helped himself liberally to whipped cream. Ali the houseboy seemed delighted that I had enjoyed eating what he had clearly so painstakingly prepared, capering around the table like a hyperactive little monkey, delivering an endless stream of incomprehensible chatter.

"He's taken quite a shine to you, my dear," the Canon said. "But I'm afraid I couldn't possibly let him go. He's indispensable to me."

A little later, sitting on the terrace in the late Sunday afternoon sunshine, we sipped strong, fragrant coffee while Ali – who much to my surprise had removed all his clothes and lay stretched out at our feet on the cool marble tiles – listened with a fascinated look on his handsome, dusky face, to our conversation.

"Don't concern yourself my dear," the Canon assured me.

"It's a traditional mark of respect where he comes from."

"What is? Stripping naked and eavesdropping?"

"Oh, he can't understand a word we say. I've taught him a few basic commands – *gin, eat, thurible, bed* and so on -but we can speak quite freely. Besides, it's his twentieth-birthday next month, and he knows he has to behave himself if he wants his present."

"What present?"

"A compact disk of *The Sound of Music*."

"Will you get it for him?"

"Certainly. But he doesn't have a machine to play it on. That'll be *next* year's birthday present. Well my dear, time for another gin, don't you think? Ali!"

Ali scrambled to his feet and disappeared through the curtained windows of the terrace. Canon le Pricque patted the smooth black buttocks as they wobbled out of sight.

"Such a sweet boy," he murmured.

I got the signature.

CHICKEN, DUCK AND VEAL

Aigullettes de Canetons au Esprit de Femme

Pollo alle Noci

Escalopes with Cream and Sherry

Fricassée de Poulet à l'Ail et à l'Estragon

Scallopine con Limone e Mela

DAME VERA FISK

Orlando Crispe writes:
As an analytical psychologist, it is probably better that Dame Vera does not delve too deeply into the reasons why duck is her favourite meat. Personally, I think it must have something to do with the fact that the taste of this succulent flesh inevitably constitutes a complex which was first embedded in her psyche when she was sexually assaulted by a young farmhand during her childhood in Market Harborough. However, since my opinion of those who tamper with the human psyche for money (especially after my experiences with Dr Balletti in Rome) is about as low as an opinion can get, let's just say she loves duck, and leave it at that.

Apparently Jung was a very attractive man, unlike that old fraud Freud, and had more women fall under his spell than I've cooked hot dinners; of course, some of them he just brushed aside, but others – Toni Wolff for example – he made full use of, so to speak. I also think he must have been rather well-endowed, because Dame Vera informs me that he was constantly making esoteric jokes about men with tiny penises. She didn't understand most of them, but then she was never a member of the inner circle. Despite myself, I think his remark to the effect that the penis is merely a phallic symbol, is rather witty.

Dame Vera was surprised to lean that I was familiar with Jung's basic theories; indeed, I mention him several times in my famous (or should I say 'infamous'?) confessions. She was also both surprised and delighted when I invited her to serve on the Executive Committee of the Thursday Club, and she takes her duties very seriously indeed. She is all in favour of opening up the Club, even though Eddie von Ströder and His Eminence Cardinal de Santis are very firmly against it;

more than this, they made their views quite plain to me in no uncertain terms. I know Dame Vera hopes that this collection of recipes and the application form provided, will encourage many more dedicated young flesh-eaters to consider joining our little confraternity. If any reader would like to write to her personally, explaining why he or she might merit special consideration in applying for membership. please do not hesitate to drop her a line via the publishers of this book. You will find her very sympathetic – but then, she *is* a woman.

David Madsen writes:

Dame Vera Fisk, who recently celebrated her 82nd birthday with a private dinner party at *Le Piat d'Argent*, is one of Europe's most prominent Jungian analysts; her list of 'sweethearts' – she prefers to use this idiosyncratic endearment rather than the term 'patients' – has included Sir Aylmer Toddington, the playwright Max Kaan, the fashion model Marianne Molloy, Yuri Turgenyiev and Bishop Chaucer Spottiswood. These and many other notables wrote of their affection for and gratitude to Dame Vera in an encomium entitled *A Woman In Depth*, published to mark the occasion of her 70th birthday.

Dame Vera was born Vera Dorothy Speight in Market Harborough, Leicestershire, the only child of Robert Speight and Lucy Speight Pickles, both civil servants working in local government. Dame Vera's first intention was to become an artist, and to this end she enrolled in the Slade School of Art, where she studied for three years; however, her first job was with a small independent film company as an assistant set designer, and for the 1948 film *White Man's Burden* starring Paul Muni she almost single-handedly transformed a large warehouse in the studio grounds into a stunningly realistic recreation of an Amazonian swamp.

It was while travelling through Switzerland in order to draw inspiration for the sets she had been commissioned to design for the romantic musical *Beth of the Mountains* that Dame Vera first encountered the great Swiss psychologist Carl Gustav Jung, the founder of Analytical Psychology. In a recent interview for *Time* magazine, she said:

"It was on a train, you know. The night express to Zurich. The sheer power of his personality overwhelmed me; he

117

emanated a kind of *force* which women in particular found dreadfully difficult to resist, even if they wanted to – and many of them didn't, of course. I dare say it had something to do with sexual magnetism too, but I wasn't aware of that at the time. All I know is that within half-an-hour, there I was, pouring out my inmost hopes, aspirations and fears to a complete stranger. Not that we remained strangers for long."

Jung persuaded Dame Vera to consider a career as an analyst, and invited her to begin studies at the recently established Jung Institute in Zurich.

"What he actually said was: 'You will come and be my disciple.' I thought it was terribly flattering, but an idiotically impractical idea."

Despite strong misgivings Dame Vera eventually decided to accept his invitation; she gave up her job with the film studio, moved to Zurich, and completed her training in Jungian analysis. She herself once remarked of this decision:

"If logic tells you it's all wrong but it feels utterly right within your heart, then do it. There's a good Jungian principle for you."

She returned to England shortly afterwards and set up in private practice in London. Within a very short time she was having to turn 'sweethearts' away, so swiftly did her reputation as an analyst grow. In 1963 she published her first book, *The Soul of Woman*; this was followed by *Mother Love, The Return of the Moon, My Prince: My Shadow*, and *Rape of the Vampire*, which won the Henry Dollinger-Prout Memorial Award.

In 1970 Vera Speight married Baron Hans-Heinrich Fisk and moved back to Switzerland, where she has lived ever since. Although too old to bear children, the partnership was a very happy one, and Dame Vera – now Baroness Fisk – was completely devasted when her husband was drowned in a boating accident on Lake Geneva after only five years of marriage. She published an account of the process of growing

through her grief, which she called *The Teardrop and the Lake.*

Dame Vera has always taken an academic interest in the psychology of eating and a professional one in the pathology of eating disorders (Dolores Kunzl, prima ballerina at the Royal Swedish Ballet, insists that Dame Vera cured her of anorexia nervosa) and – not surprisingly – Dr Leo Klein claims that 'the sparks always fly' whenever he is seated next to her at Thursday Club Committee banquets. Orlando Crispe admits that he always takes advantage of Dame Vera's knowledge and experience when he is called upon to create a new dish to meet the specific requirements of a particular client.

Dame Vera Fisk is the only woman on the Executive Committee of the Thursday Club; she is also the member who is considered to be most 'sympathetic' towards unpromising applications.

Aigullettes de Canetons au Esprit de Femme

FOR TWO PEOPLE

2 duckling breasts
1 lb (450g) unsalted butter
2 tbsp fine cognac
3 tbsp port
Juice of 1 freshly squeezed orange
Grated nutmeg
¾ pint chicken stock
1 lb (450g) stoned black cherries
Salt and black pepper to season

Buy a largish duckling and lift each breast off in two pieces with a filleting knife inserted on each side of the middle breastbone. Or get your butcher to do it for you.

Enlist the assistance of a loving female colleague. Have her strip naked and lay on her back on a comfortable bed, a soft pillow beneath her head. Tenderly spread her legs. Carefully insert the duck breasts into her vagina and let them marinate there for three or four hours. Your colleague may sleep if she wishes; I recommend that some soothing music be played, such as Satie's *Gymnopedies I, II, III*. I tell you here, that the final flavour of the dish will be much improved if you have intercourse *before* marination, but *without* permitting yourselves to reach a climax; a little *coitus interruptus* works wonders, believe me.

No-one should be surprised at this exotic method of marination; women in the Middle Ages frequently inserted fish into their vaginas before frying them for their husbands – this was both to ensure fidelity and to arouse desire. Penitentials of that period give a quite specific penance for this somewhat *outré* misdemeanour: seven days on bread and water. Indeed, it was browsing through Canon Roderick le Pricque's *Penitential Practices of the Medieval Church*

that inspired me to add my own particular touch to this well-nown French classic, which specifies Monmorency cherries. In fact, any dark variety will do.

The breasts used to create my verson of this dish were taken from a 'lady' well-known in certain circles for her lavish distribution of sexual favours, and my dear Jeanne marinated it herself. Gressingham duck is specified as the perfect substitute.

After marination is complete, remove the duckling breasts from your colleague's vagina, salt them lightly, and immediately sauté them in a deep pan over a moderate heat, turning them once. Ideally, the flesh should be half-cooked, pinkish in colour. Drain off the butter, pour in the cognac and set it alight. When the flames have died, season the breasts with the nutmeg, salt and pepper. Remove and keep warm.

Now add the port to the pan, deglazing the juices. Put in the orange juice and reduce by half. In a clean saucepan heat the stock, then pour in the liquid from the pan, stirring well. Add the cherries and poach them in the saucepan without bringing to the boil. Put the duckling breasts into the sauce and heat them through. Remove, drain and slice into fillets. Arrange them on warm plates and pour over half the sauce, reserving the remainder for the sauceboat.

From *The Unpublished Diaries of Orlando Crispe*

Count de Castrès eased himself back in his chair and closed his eyes; the candlelight flickered across his gaunt face to make him look like one of his own carvings. There were dark, deep shadows around his eyes, and his neat beard sparkled, glinting, as if someone had threaded it with tiny jewels.

"I too know what the love of beauty is," he murmured, his voice barely a whisper.

"I have never claimed that as my own personal perogative," I said, and I saw him smile.

"I knew a girl once, no more than seventeen or eighteen years old at the most, living with her family in a farmhouse near my studio. She delighted in simple, natural things – contemplating the sky, talking to the birds – and she knew what was beautiful and what was ugly with an unerring instinct; people who constantly commune with nature have that gift, you understand.

"She was beautiful. I do not think that such perfect beauty and loveliness can ever exist without causing pain to others, do you? Because to look upon it is inevitably to desire it, and to desire it is to yearn for the impossible – for when the object of such desire is possessed, it is also destroyed. Wasn't it that old queen Wilde who said that each man kills the thing he loves? You see, part of the perfection of this kind of beauty is *not to be* possessed – possession renders it imperfect, and therefore no longer the object of desire and yearning.

"I loved her from far off – that was the essence of it. I loved her so much. I did not think it was possible to love another creature that much. I would have given everything for a single glance from the clear, unhesitating eyes, for a smile from those

123

delicate lips – my life, even, for one touch of her lips against mine!"

I coughed discreetly.

"I used to watch her come out of the house into the little courtyard to wash at the pump there – for they had neither running water nor electricity nor any modern convenience – since the windows of my studio overlooked the place; I would rise at five in the morning, when the light of dawn had come but not yet gained strength, and the sky was nacreous, the faintest, most milky of pinky-turquoise. There was just her, and me watching her, and the song of birds. Eden mist have been precisely so, newly slipped from the hand of the Creator, still wet with dew from the uplands of heaven, barely separated from the earth.

"Her body was perfect, flawless. In that first fragile light, it was like the marble I so inadequately hack at – smooth, seemingly translucent, pearly white. Her nipples fat as hazelnuts, stiff with the cold, the plump glory between her legs crowned with a halo of fiery copper hair, like the head of an emperor crowned with laurel. She was young, but she was full of power! I saw it when she bent down to work the pump: her small buttocks were a miracle of taut, self-contained muscle, her calves tense with coiled strength, her dear toes spread on the cobbles to support and balance her weight, her slim hands turning the handle of the pump with such casual grace. I harboured a secret fantasy about those toes: that one day I would persuade her to let me paint them with my tongue – dipping the tip of it in the rich crimson colour and applying it to each darling little nail!

"Every morning I watched her wash herself and every morning I ached with love, I burned up with the fever of yearning, and I loathed the sight of my own grimed, work-stained body. Gazing on her was a trial by beauty, and there was no occasion on which I was not accused, condemned and sentenced – it was a pain almost impossible to bear, yet I could

not desist, I could not stop it. Silently, wordlessly – for who was there to hear and, hearing, to understand? – I gave her my heart to do with as she wished, even to squeeze the blood entirely out of it with one strong young fist; yet to my infinite disappointment my heart continued to beat on, and I continued to suffer.

"In my dreams I fondled her sweet breasts, the flesh firm beneath the taut skin, caressing them until she cried aloud, begging me to cease because the pleasure was too intense; I covered her lovely mouth with my kisses, her limbs entangled with mine; I felt myself easing my aching member into the juice-rich heat of her tight, swollen-lipped opening; in my darkest nightmares I saw her smiling at me and beckoning, but moving ever further from my reach. I was, I think, literally sick with love! Oh, I know what a tired, promiscuous phrase that is, and I am aware that bad poets have abused it mercilessly, yet I believe it to be entirely accurate in this particular case. I could not eat, I could not sleep; I took refuge from my pain in alcohol, but even my drunken stupors were disturbed by the erotic and the obscene. Other people, other things, became unreal to me, and I related to them only with the greatest difficulty and by an immense effort of will. She alone was my reality, she alone my truth and my light. The few friends who came to visit me thought that I had gone mad – and indeed, they were not wrong. It was the madness of infatuation."

Count de Castrès stopped speaking and looked across at me through half-closed eyelids.

"What are you thinking of, Orlando?" he murmured.

"I'm thinking," I replied, "what wonderful *Aigullettes de Canetons au Esprit de Femme* she would have made."

From *Confessions of a Flesh-Eater*

It is entirely amazing that the leanest part of the duck – indeed, the *only* lean part really, for *magret* means 'lean' – was, until three or four decades ago, the part no-one really bothered to use. The thighs for example (and also the drumsticks) are cooked and then preserved in fat to be used in the winter months for a whole variety of different dishes; the gibblets and the bones are used to enhance and enrich soup, and I hardly need to mention the heavenly *foie gras*. But the breast? Ah, now we really *know* what to do with the breast! Grilled or sautéed, served blood-rich, sumptuously pinky-rare, it compares to the finest entrecôte, in my opinion. They may also be steeped in marinade or glazed, cooked with citrus fruits or fruits of the forest, served with *pommes frîtes* or potato *purée*, with cherries, peaches, white grapes or chunks of apple – oh, these tender slices of flesh lend themselves to an almost infinite spectrum of possibilities!

Pollo alle Noci

8 skinned chicken quarters
3 cloves of garlic, roughly chopped
½ cup of halved walnuts
1 bayleaf
4 tbsp olive oil
1 cup of chicken stock
8 tbsp mayonnaise
3 oz (75g) Parma ham cut into strips
Salt and black pepper to season

Put the garlic, walnuts and bayleaf into a large pan and fry gently in the olive oil for about 5 or 6 minutes, or until slightly soft. Then drain off these ingredients and set them aside. Season the chicken quarters then fry them in the oil, turning occasionally, until they are nicely golden. Put the garlic, walnuts and bayleaf into a mortar and grind to a thick, paste-like consistency. Thin this with the chicken stock and pour over chicken quarters. Simmer gently for about 30 minutes. Then remove the chicken, set aside, and keep warm. Add the Parma ham to the liquid in the pan, and whisk in the mayonnaise to thicken it. Put the chicken quarters back in the pan. Keep this on the heat for about 5 minutes, but do not allow it boil. Serve immediately.

From *The Unpublished Diaries of Orlando Crispe*
Tuesday 14th May 19— —

On Wednesday, as Heinrich had threatened she might, Signora Bianco-Bianchi came to partake of lunch – she insisted on being taken up to the roof garden – and, unsurprisingly, revealed an appetite as prodigious as Henrich's; but before I even had time to show her the menu of the day, and with the same disgraceful immodesty that characterised her fat blackmailing friend, she announced that she too would sing. What is it about tenors and sopranos that they just cannot resist the opportunity to make themselves the centre of attention? What do they have in them that impels them to cast all consideration, courtesy and discretion aside in order to indulge in such vulgar displays? As far as I know, neither baritones nor contraltos go around behaving in this reprehensible manner. Their grotesque egoism I can understand, for when one is constantly assuming the character and temperament of famous kings, queens, well-known personages of significant historical import and minor assorted divinities, regarding the rest of the human race as trivial riff-raff must inevitably be a professional hazard that is difficult – if not impossible – to avoid; but this urge to cheap self-advertisement, to frank and simple showing off? I just did not understand it – but I certainly had to suffer it.

Signora Adelina Bianco-Bianchi opened her mouth and began to sing. That, baldly stated, is what she actually did; what it *appeared* to be however, was something utterly different. It appeared to be the stuff of nightmares.

The lavishness of the mouth passed through generosity to profligacy, becoming a vast, yawning chasm into which, like a black hole, one might imagine everyone and everything

within a ten yards radius would be precipitately sucked, never to emerge again – or, worse still, to emerge on some ghastly 'other side' in hideously mangled and reassembled genetic chaos. Things moved in that gorge of a mouth – tonsils the size of crab-apples, an undulating uvula, a massive pink and grey slug that was her tongue, vibrating within itself at immense speed and at the same time swaying with – yes, the analogy is entirely appropriate – with slug-like stealth from side to side.

The sound that emerged, like a maniac from years of solitary confinement, was an assault worthy of the D-Day landings: wave after wave poured out, resisting every attempt at repulsion, slowly and surely gaining ground until it possessed the entire shoreline of one's aural cavities. Wild pigs snuffling happily through the pines of the Campagna Romana must surely have quailed and fallen, mortally stricken by that piercing sonic beam.

The great body wobbled precariously on its axis; the envelopes of yellow, veined flesh that hung from the undersides of her arms flapped as she lifted up her hands in operatic supplication; the monstrous breasts heaved and seemed for a moment to move in different directions – a feat I considered improbable but possible, in the circumstances; the fat stump of each nipple beneath her tight white dress was clearly visible, and it became suddenly obvious that Signora Bianco-Bianchi was not wearing a supportive undergarment – quite disgraceful in a woman of her age and build, I thought.

"Dein Mund ist röter als die Füsse der Männer, die den Wein stampfen in der Kelter. Er ist röter als die Füsse der Tauben, die in den Tempeln wohnen!" she screeched, reaching a stratospheric note whose position above the stave must surely have required a considerable number of additional bar lines.

It was unfortunate, to say the least, that she had chosen to sing something from Richard Strauss' *Salome* – a gentle Schubertian lullaby would have been infinitely more

appropriate; as it was, Strauss' predilection for wild vocal acro-
batics at a volume designed to be heard above a fifty-piece
orchestra with additional percussion going at full throttle, gave
Signora Bianco-Bianchi the excuse she needed to show what
she was made of. But then, I mused, could a woman like her
have *ever* needed an excuse?

*"Dein Mund ist wie ein Korallenzweig in der Dämm'rung des
Meers, wie der Purpur in den Gruben von Moab, der Purpur der
Könige . . . "*

It was definitely becoming painful. Fortunately, I knew that
she was nearing the conclusion of her pyrotechnic rhapsody
on the precise quality of the redness of John the Baptist's
mouth, and yet – as is so often the case with Richard Strauss –
the most ear-splitting high-C shrieks are saved for the end; I
was torn between relief and dread, and as Signora Bianco-
Bianchi screamed on, dread inexorably began to get the upper
hand.

*" . . . nichts in der Welt is so rot wie dein Mund. Lass mich ihn
küssen deinen Mund!"*

(Quite properly, John the Baptist refuses this scandalous
importunity.)

*"Ich will deinen Mund küssen, Jokanaan! Ich will deinen Mund
küssen!"*

And now here it came, the pitch above all pitches
expressing a fury above all furies and a desire transcending all
desires:

*"Lass mich deinen Mund küssen, Jokanaan! Lass mich deinen
Mund küssen!"*

And John the Baptist, in rather more scriptural terms than
mine, tells her to piss off, then retires to his cistern for the
night.

Signora Bianco-Bianchi sank perilously to her knees;
her fat, white, beringed hands were clasped together as if in
prayer – quite an inappropriate gesture I thought, considering
the litany of lust she had just delivered – her thyroidal eyeballs

turned up to heaven. An imaginary piano crashed out its final dissonance.

I walked over to help her up and nearly wrenched my arm out of its socket in the process.

"You like, yes?" she gasped, one of her chins quaking visibly, the others merely trembling in an ovine willingness to be shown the way.

"It was extraordinary," I said, kissing her hand and cutting the tip of my nose on one of her rings. "I've never heard anything quite like it."

"Si, dey say dat. Dey say I am unique among *tutte le prime donne*. I like to tink so. But – what is diss on de nose? *Sangue?* Oh my God, blood!"

"It's nothing," I said, quickly wiping it away with my hankerchief. "Probably a light nosebleed. I always get nosebleeds when I'm excited."

"Aha!" she giggled coquettishly, "you are excited by my perrrformance, yes?"

"Well –"

"Don't be ashamed, Maestro. No! Never be ashamed. It is powerrrful music, diss Ricardo Strrraus. *Salome* is very strong, very sexy. It is – how you say it? – music of the great orrrgasm, yes? Oh, I love to sing diss music! I am famous for it."

"I dare say."

"Dere is much *sangue* in diss music also, much *sangue* when Salome kisses de cut-off 'ead of Jokanaan. First she – *szoop!* – take away de 'ead, den she kiss de mouth. It is all about love. Ah, *l'Amore, l'Amore!*"

"I have prepared a table for you, Signora. A private table, of course."

"Oh!"

"Will you be so kind as to follow me?"

I felt her hot breath on my neck as we crossed the roof garden.

I gave her *tagliatelle* with truffles and toasted pine kernels in a light cream and brandy sauce. Then *pollo alle noci* accompanied by puréed spinach. And *torta della nonna* – 'Granny's cake.'

"Perrrfect," she purred, slurping down her double espresso. "Yes, *perfetto. La carne bianca – meglio per il cuore, si dice. E la torta della nonna – un dolce proprio da paesano.*"

"I'm glad you liked it, Signora."

"And in return – *una cortesia, capisce?* – I will sing for you again."

"Again?"

"But of course! You are kind to me, so I am kind to you."

Was this fat-swathed screecher trying to get out of paying the bill?

"Signora, I really think –"

"Yes, yes, I know what you will say – it is too good of me, you protest dat I sing too much for you –"

"That, certainly."

"But after such a *buon' pranzo*, I must return the *complimento.* I will sing an aria from *Norma.* You would like *Casta Diva*, yes?"

"No," I said.

"I cannot sing *Mira, O Norma* – it is a *duetto.* You understand?"

"Only too well, Signora. But I must insist –"

"Signor Creespe – if you will not allow me to sing – what can I say to such *gentilezza?* I don't know de words for such a big *grazie* – "

I could see she had no intention whatsoever of paying the bill.

"You needn't bother," I said. "I'm sure I'll think of something."

She looked up at me and smiled. There were too many teeth in her mouth – too many for any practical purpose, at any rate.

135

"Yes, tink of someting. Some liddle ting. Dat would please me – oh yes, it would please me."

"I'll let you know," I said.

She rose mountainously from her chair and wobbled her way across the terrace.

Escalopes with Cream and Sherry

4 bonned, skinned chicken breasts
1 egg, lightly beaten
4oz (100g) freshly-made white breadcrumbs
2 tbsp finely chopped parsley
1 tbsp milk
3 tbsp olive oil
2oz (50g) unsalted butter
4 tbsp dry sherry
5 tbsp single cream
Salt and black pepper to season

Mix together the breadcrumbs and chopped parsley. Flatten the chicken quarters with a rolling-pin. Mix the beaten egg with the milk and season with salt and black pepper. Dip each flattened chicken breast first in the milk, then in the combined breadcrumbs and parsley. Fry in the oil for about 7–8 minutes, until thoroughly cooked. Set aside and keep hot.

Melt the butter in a saucepan and add the sherry. Next add the cream, stirring gently all the time, and heat through until thickened. Serve the chicken breasts on warm plates and spoon the sherry sauce over.

The Soul of Poultry

Poultry, especially chicken, is grey in soul. This might at first seem somewhat surprising, but one must remember that grey is the colour of intellectual feebleness – and whatever one may say about chickens, they are certainly not the most intelligent of creatures. Actually, they have always struck me as rather frivolous, foolish things. Be that as it may, chicken flesh lends itself admirably to some of the most subtle and delicate of dishes. Furthermore, you must imagine a light – almost translucent – grey, spangled with splashes of silver; for the character of the chicken is entirely superficial, chattery, brittle and – synaesthetically speaking, at any rate – like the tiny prickling of a myriad needle points.

Chicken is everything that is sharp-edged and glassy; it is like the bracing tang of fresh-cut limes, salt spray cutting across reddened cheeks, a November wind, the clean fragrance of daffodils; like the gleam of a newly-honed kitchen knife, the *piinng!* of crystal flicked with a fingernail, the acidity of cut grass. Musically, the instrument that best represents the soul of chicken is the triangle – which, of course, can even be heard above a fifty-piece orchestra going at full throttle. The xylophone is also very close to it. Olympia the automaton's aria *Die Vögel im Laubengang,* from Offenbach's *Les Contes d'Hoffmann*, is the perfect musical accompaniment to any chicken dish.

Jackson Pollock was a 'chicken painter' *par excellence*, but there is also a measure of the chicken's soul to be discerned in the work of Francis Picabia – I am thinking, for example, of the brittle, acutely-angled mechanics of his *Amorous Parade*, painted in 1917. There is something mechanical, something of the automaton, about the chicken: it pecks, it jerks, it hops

and skips, and its squawk rather reminds one of the harsh momentary grinding of unoiled gears.

Good chicken stock is a culinary essential, and so many of the finest dishes call for it; it can be prepared, cooled and frozen until it is needed, and there is absolutely no excuse for the unspeakable *chicken stock cube*.★ The chef who uses one – as, I am afraid to say, Monsieur Charles Pamploni of *Il Sogno Blu* here in Geneva does – is a traitor to his high calling. Monsieur Pamploni and I are old enemies, and he has often insulted me in various trade magazines and journals; nevertheless, if he imagines that to denigrate my genius will somehow have the effect of raising his own mediocre talent to a similar level, he is sadly mistaken. I once ate an *Épaule d'Agneau au Curry* prepared by that mountebank, and I was almost sick.

★ *See Appendix II for my own observations on the preparation of stock.*

Fricassée de Poulet à l'Ail et à l'Estragon

4½ lb (2kg) chicken
10 cloves of garlic, unpeeled and whole
3 tbsp fresh tarragon
1 glass of very dry white wine
2 tbsp olive oil
8 fl oz (225ml) good chicken stock
Salt and black pepper to season

Preheat the oven to 200° C/400° F, gas mark 6. Remove the skin from the chicken and cut into 6 pieces, to serve 6 people. Heat the oil in a flameproof casserole dish, season the chicken with salt and black pepper, and brown as quickly as possible, turning once. Lower the heat and add the garlic cloves. Cook for between 6 and 8 minutes until the garlic has softened. Then add the tarragon and stir the wine and the chicken stock. Bring rapidly to the boil then transfer to the oven. Cook uncovered for about 20 miniutes. Next, remove and give the contents a gentle stir. Replace and cook, covered, for a further 20 minutes, or until the chicken is tender. To serve, put the chicken on plates and set aside, keeping hot. Strain the liquid and remove all the solids. Pour over the chicken before bringing to the table.

Scallopine con Limone e Mela

4 large veal escalopes	
2 tbsp plain flour	
1 oz (30g) butter	
1 glass good dry white wine	
The juice of one large lemon	
Black pepper to season	
1 cooking apple, peeled and finely chopped	

Beat the escalopes gently with a rolling pin, until they are fairly flat. Dip them into the flour so that they are lightly coated all over. Melt the butter in a pan and fry the escalopes for two minutes, first on one side then the other. Add the lemon juice, the wine, and cook for about 1½ minutes until about half of the liquid has evaporated. Then remove the escalopes and set aside, keeping warm.

Put the chopped apple into the pan, and cook for a few moments in the remaining liquid until softened and golden in colour. Stir well. Serve the escalopes with the sauce poured over, and accompany with puréed spinach.

The recipe given here was served at a private dinner party for Gianpietro Alessandro, Bishop of Tre Fiumi, and his mistress Donatella Pomponi. This liaison between the Bishop and – yes! – the actress was an open secret, but was for some ecclesiastically political reason tolerated by the Vatican; or at least, they certainly turned a blind eye to it. What neither the Vatican nor Alessandro and the carmine-lipped, full-breasted Signorina Pomponi most certainly did not know however, was that the *Scaloppina con Limone* was made with the tender young flesh of a Roman prostiutute. Bishop Alessandro, after all, had requested me to create and serve a dish *to further the progress of love* – well, I think I did exactly this. I would suggest – indeed, I am obliged to insist – that you use veal when you prepare this dish, as I did when I served it to Cardinal Antonio de Santis for the first time.

APPENDIX I

DAVID MADSEN

The pseudonym 'David Madsen' conceals the identity of a philosopher and theologian who was born in London of Danish parents; he spent most of his childhood in Copenhagen, where he now lives, although he also maintains homes in London and Rome. Madsen says that from a very early age he has been fascinated by esotericism, heresies, the occult and all things mystical; he claims a very particular interest in historical manifestations of the philosophy known as dualism, of which the Christian gnostic sects – such as the Cathars – are perhaps the most widely known examples in the west. In his early twenties he went to live in Rome, where he studied the writings of the great gnostic masters; he was given permission to work in the Vatican Library and – to his astonishment and delight – was granted access to many of the ancient texts which are kept there under lock and key. The result of eight years of study was *The Principles of Gnostic Soteriology*, published by the Alexandrine Academic Press.

Shortly after leaving Rome to return to Copenhagen, David Madsen had what he describes as a "profound mystical experience" whilst praying in a small country church in Jutland. Pressed to elaborate on this, he says that he was given "a sudden and unexpected intellectual illumination of incandescent clarity, an almost blinding perception of the fundamental unity of all created life, an incontestable knowledge of the *oneness* of everything that exists, and – with the selfsame clarity – a comprehension of the living Presence within Whom this oneness is sustained." Madsen was later to claim that this experience completely altered his way of relating to the world and to other people; it certainly changed his lifestyle, for he very soon afterwards went off to India for a year to take instructions in the spiritual life from the Sufi master,

Nahyat Humin Khan. However, he remains reluctant to speak about the precise nature of these instructions, or of what passed between master and pupil during this time.

In 1989, feeling that the Lutheran Church into which he was baptised did not adequately satisfy his taste for either esotericism or ritual, Madsen became a member of the Liberal Catholick Church of Scandanavia, which claims apostolic succession through Mar Karolus II and Mar Terry; it was at this time that he made the acquaintance of Canon Roderick le Pricque. Two years later he was given Minor Orders and became a Doorkeeper in the Church; Madsen takes his clerical status very seriously, and always makes a point of wearing his collar at ecclesiastial functions. In 1990 Madsen's father – a well-known Copenhagen antiquarian – died of a heart attack, leaving him a substantial amount of money in the form of an annuity; sadly, Madsen and his mother became irreconcilably estranged when he made this legacy over to the trustees of the Liberal Catholick Church of Scandanavia. Anna Madsen-Brøget attempted to prove in court that Bishop Hans-Johannes Hägen had exerted undue influence over her son, but was unsuccessful.

In March 1994 David Madsen was asked by Professor Tomasz Vinkary of the University of Budapest to translate and edit the memoirs of Giuseppe Amadonelli, a dwarf who lived in 16th-century Rome, belonged to a gnostic sect, and became an intimate of Pope Leo X. Madsen himself was intensely interested in the manuscript that Vinkary had discovered, not least of all because it included much philosophical speculation of a dualistic nature, and contained at least two descriptions of gnostic initiation rituals hitherto unknown to academics and experts; he therefore accepted the task gladly, and *Memoirs of a Gnostic Dwarf* was published by Dedalus in March 1995

Madsen made the acquainance of Orlando Crispe in Rome, and was a regular customer at *Il Giardino di Piaceri*.

Shortly after Crispe had moved to Geneva to take over the management of *Le Piat d'Argent*, Madsen persuaded him to set down his story in the form of a long 'confession'; this he did, and *Confessions of a Flesh-Eater* was published by Dedalus in April 1997 with the special co-operation of Helmut von Schneider, Orlando Crispe's legal advisor and a fellow enthusiast for the exquisite delights of flesh-eating. After Helmut von Schneider resigned from the Executive Committee of the Thursday Club, Crispe invited David Madsen to fill the vacant position, which he was happy to do. Unfortunately (and despite his protestations to the contrary) he is known to be the least sympathetic of all the Committee members, and tends to judge new applications – particularly those which appear unpromising – rather harshly; he is of the opinion, for example, that persons applying for membership of the Thursday Club should possess at least one recognised professional or higher academic qualification, but is willing to consider any piece of published non-fiction writing in lieu. It should be stressed that this opinion is not necessarily shared by the other members of the Executive Committee – indeed, Dame Vera Fisk is completely opposed to it.

APPENDIX II

THE MAKING OF STOCK

I have written somewhat bitterly about the ghastliness of the now ubiquitous stock cube, but this is because my genius impels me towards perfection in my art, and shoddy half-measures designed to save time and energy are anathema to me. What if Caravaggio, having completed the human figures in – say – *The Entombment of Christ*, had painted the rest of the canvas blue in order to 'save time'? Even Schubert preferred to leave his symphony unfinished rather than round it off with a couple of quick chords before he died. The art of creative cuisine demands unreserved dedication, within which the stock cube has no place. A first-class stock is the very essence of the flesh from which it is extracted; it is, if you like, the alchemists' *lapis philosophorum* which can accomplish all things – wondrous things, things enticing, rich and rare. It is a building block on which the most exquisite creations can be firmly based. When stock is properly reduced – thick and glistening! – it is of more value to the masterchef than liquid gold.

The psyche of the culinary artist must encounter and enter into a relationship with the psyche of the flesh which is to produce the stock. There must be a symbiosis – this much will be obvious to anyone who understands the basics of the philosophy of Absorptionism – and such a process can be effected in two fundamental ways: the emotional and the physical. I generally prefer the physical, but I have sometimes combined the two in what I would call the *holistic* method. I do not greatly care for this word with its superficial, New Age connotations, but – *faute de mieux* – it is a reasonably accurate description of what is involved. With the emotional method, one uses visual images, music, prose etc., to attune oneself to the soul of the flesh being used; with the physical method,

direct contact with the flesh of the chef is required. In the making of chicken stock for example, one might choose to listen to certain passages from the music of Offenbach (a 'poultry composer' *par excellence*) or contemplate the paintings of Cy Twombly – I am thinking in particular of his *Bolsena*, in oil, coloured chalk and pencil on canvas. Personally, I find this work ridiculous – but then I find chickens ridiculous too, so the match is perfect. I once made a tape-recording of someone dropping wine glasses onto a marble floor – two hours of it – and I played it quietly in the background whilst preparing chicken stock. The result was stunning.

The bones of the bird are probably rather more important than the flesh, which is why leftovers from a roast chicken serve admirably: wings, legs, little spiney bits and pieces – and also some of the skin. The fat which this produces is skimmed off in any case. and skin always adds flavour. I would put these leftovers in a saucepan containing a couple of pints of water, addding a coarsely chopped onion, a clove of garlic still in its skin, a few carrots, turnip and half-a-dozen whole peppercorns. Then I would bring them to the boil and lower the gas, leaving them to simmer for at least 1½ hours, adding a little more water if necessary. After this the stock should be strained into a clean saucepan and everything else discarded. Any scum or fat is now skimmed off. Personally, I would reduce the resulting stock by half.

From *The Unpublished Diaries of Orlando Crispe*
Friday 2nd June 19——

Friday nights were always bath nights, and throughout the week I relished the joy to come, treasuring it in my heart and contemplating it as the seraphim are said to contemplate ceaselessly the unformed Godhead.

I made my preparations in the morning by roasting twelve large joints of prime beef and collecting the juices from the bottom of the roasting tin – including the browned ichors of the flesh – by deglazing them in red wine, then reserving them in a warm saucepan; there would be, I suppose, a couple of pints of this precious liquid by the time the process had finished. I left them to cool.

In the evening I made up a gallon or so of beef gravy, adding to it a bottle of my finest *Condrieu Coteaux de Chery, Andre Perret 1992*. I know that many of my critics would consider this a shocking extravagance – while my enemies would say frankly that it was a criminal waste – but for the ritual of Friday night, every element and aspect had to be thoroughly considered, everything of the best, for this was a work of both spiritual inspiration and intellectual accomplishment which demanded nothing less than perfection. I am quite aware that those with a lesser creative talent than my own will not readily sympathise, but I do not regard this as my problem. To the enriched gravy I added the cooled meat juices and carried the resulting liquid upstairs to my bathroom.

I lit candles: softly glowing, perfumed, pastel-shaded candles – in great abundance. I played music: Enrico Nomenti's *Brass Serenade*, the *Dies Irae* from Verdi's *Requiem* and a trumpet concerto by Vivaldi. I filled the bath with my

beef stock, topping it up with hot water. Then I divested myself of my clothes, undressing slowly and carefully, consciously aware of the powerful eroticism at the heart of the situation. I would always be aroused but never fully erect, in a state of acute anticipation, but not excitation. I stepped into the bath and lay back, luxuriating in the warmth, relishing the meaty fragrance. Embraced by my beloved! Swathed in her precious juices! Like a child in swaddling clothes, like a foetus in amnotic fluid, and an osmosis of love came into being, a breathing and an inbreathing, lover and beloved commingled and lost, one in the other.

I slipped lower into the bath, regulating my movements by pressing my toes against the taps, until the rich, thick, golden flesh-stock whirled and eddied over my hairy belly, like sea-water in a crabpool at the oneset of the outgoing tide, filling my navel and creeping up over my chest. The sweet perfume of meat was overpowering. To have one's naked body tickled with feathers would not have been a fraction as delicate or as subtle a sensation as this! Finally, I allowed myself to be submerged up to my chin, so that the slick, greasy liquid entirely covered me. By rapidly clenching and unclenching my sphincter muscles, I discovered that I could actually draw some of my beloved's fluid up into my back passage, and this caused in me an intense delight, for it was, in a very real sense, an act of intercourse; but the final consummation came when I allowed a small amount of urine to ooze out from the tip of my penis, and the two kinds of bodily juices became inextricably blended, inseparable, just as (so the eastern sages say) the shining drop becomes the infinite ocean.

This spectacular bathful of stock was subsequently used to create many equally spectacular dishes.

BIBLIOGRAPHY

Orlando Crispe Recommends

CUISINE

The Art of Meat – Sylvia Lacordaire
Rickworth & Sadler Books, London 1987
Now a popular modern classic, Lacordaire's lucid exposition of the art of choosing, preparing and cooking all kinds of meat from sweetbreads to fillet steak, is an excellent guide for beginners and a reliable friend for the bookshelves of advanced chefs.

Meat for Men – Clive Montmorency
Pink Press, London 1993
A gay perspective on the libido-enhancing properties of meat, especially beef. Not for the prudish.

Flesh for One – Egbert Swayne
Dedalus Ltd, Sawtry, 1998
Dedalus is currently considering a reprint of this excellent cookbook, which concentrates on easily-prepared meat dishes for the single person. It features several of Egbert Swayne's most celebrated creations, including 'Pork Loin with Cashew, Vodka and Sultana Stuffing'. Contains a foreword by Orlando Crispe.

Beef and Lamb Dishes from Around the World – Louise Drinkler
Schumacher-Gabriel Verlag, Munich, 1993
Drinkler's book will not present a challenge for experienced culinary masters, but amateurs will find it invaluable.

Carnivore Omnibus – ed Bradley Comber
Krayne & Weintraub, New York, 1981
A splendidly ghoulish investigation into the more obscure
delicacies of flesh-eating, including braised lamb's ears and
pan-fried pig's colon. A must for devotees of offal.

101 Classic Meat Dishes – Kirsten Price
Karnaby Ltd, Auckland, 1972
Karnaby was once the leading cookery publisher in New
Zealand but went out of business after being sued by an
Auckland housewife who, following one of the recipes in
Price's book, punctured her windpipe on a chicken-bone.
Nevertheless, it remains a standard of the repertoire.

THE PHILOSOPHY OF FLESH-EATING

The Fundamental Principles of Absorptionism – Orlando Crispe
Alexandrine Academic Press, Oxford, 1998
The basic textbook for anyone interested in the philosophy of
Absorptionism, with an introduction by David Madsen.

Meat-Eating and Masturbation – Dr Elgar Feldmann
Analytical Psychology Books, Chicago, 1989
Elgar Feldmann is not only famous as an Adlerian psycho-
analyst, but also for assaulting Carl Jung in a Zurich street in
September 1959. This book examines the psychological links
between meat and sexual autolatrism.

Why Vegetarianism is Wrong – Rev Canon Roderick le Pricque
Badearth Publishing Company Ltd, Brisbane, 1999
The Canon's lighthearted look at how vegetarianism causes
indigestion, uncontrollable flatulence, myopia and embarrass-
ing membrane irritation. He cites Adolf Hitler as a typical
example of what he calls the 'vegetarian syndrome.'

APPLICATION FOR MEMBERSHIP OF THE THURSDAY CLUB

Le Piat d'Argent, Geneva

PRESIDENT: ORLANDO CRISPE

All applications will be carefully considered by the Executive Committee of the Thursday Club, whose decision is final. Only successful applicants will receive the appropriate notification.

SURNAME FORENAME(S)

TITLE(S)

NATIONALITY ...

DATE OF BIRTH ...

DOMICILE 1 ..

.............................. TEL

DOMICILE 2 ..

.............................. TEL

OTHER(S) ..

PROFESSION/OCCUPATION ..

EDUCATION (SCHOOL, UNIVERSITY, INSTITUTE, ETC)

...

...

...

...

PLEASE STATE WHICH LANGUAGES (EXCLUDING ENGLISH)
YOU SPEAK WITH REASONABLE FLUENCY

1 3

2 4

PROFESSIONAL/ACADEMIC QUALIFICATIONS

...

GROSS ANNUAL INCOME PERSONAL TAX CODE

PUBLICATIONS/ARTICLES
(PLEASE INDICATE TITLE, PUBLISHER AND PUBLICATION DATE)

...

...

LEISURE INTERESTS

...

...

HAVE YOU EVER DINED AT EITHER
IL GIARDINO DI PIACERI OR *LE PIAT D'ARGENT*?

 YES _____ NO _____ (PLEASE TICK)

GIVE THE NAMES AND ADDRESSES OF TWO PEOPLE WHO WOULD
BE WILLING TO SUPPLY A TESTIMONIAL IN SUPPORT OF YOUR
APPLICATION

1 2

ARE YOU KNOWN TO ANY MEMBER OF THE COMMITTEE?

 YES _____ NO _____ (PLEASE TICK)

ARE YOU RELATED TO ANY MEMBER OF THE COMMITTEE?

 YES _____ NO _____ (PLEASE TICK)

IF YOUR APPLICATION IS SUCCESSFUL, WOULD YOU BE ABLE TO
TRAVEL TO GENEVA FOR THE BI-ANNUAL EXECUTIVE COMMITTEE
BANQUET?

 YES _____ NO _____ (PLEASE TICK)

PLEASE STATE IN NOT MORE THAN 500 WORDS WHY YOU
WISH TO BE CONSIDERED FOR MEMBERSHIP OF THE THURSDAY
CLUB. YOU SHOULD INCLUDE A BRIEF ACCOUNT OF YOUR
PERSONAL PHILOSOPHY OF FOOD AND THE CULINARY ARTS. USE
A SEPARATE SHEET TO DO THIS AND ENCLOSE IT WITH YOUR
APPLICATION.

All applications should be submitted to:

Count Menzies McCrampton
The Thursday Club Executive Committee
c/o Dedalus Ltd
Langford Lodge
St Judith's Lane
Sawtry
Cambs PE17 5XE
England

The Executive Committee of the Thursday Club regrets it is unable to enter into any correspondence with unsuccessful applicants.

Confessions of a Flesh-Eater – David Madsen

'Going to Rome? Don't eat at *il Giardino*, the outrageous new restaurant where meat's marinated in body fluids and you never know where the chef's hands have been. The author of *Memoirs of a Gnostic Dwarf* returns with a nasty tale of culinary perversion.'
 The Independent on Sunday Summer Reading Selection

'. . . an intriguing flavour'
 The New Statesman & Society

'From the author of *Gnostic Dwarf* comes a vile but mouth-watering new confection. A famous cook, jailed for cannibalism, recounts his killing career and the best recipes for human flesh. *Ready Steady Cook* was never this fun.'
 Roger Clarke in Attitude Magazine

'Literary horror novel, an extravaganza about cannibalism.'
 Interzone

'Admirers of David Madsen's extraordinary first novel *Memoirs of a Gnostic Dwarf* will not be disappointed by his second. *Confessions of a Flesh-Eater*, in which, once again, erudition is combined with eroticism to create a book both highly diverting and drolly informative. An unmissable treat about a stylish monster.'
 Gay Times Book of the Month

'Set in the present, the tale has all the grim foreboding of a genuine Gothic work. Its tone and emphasis owe much to James Hogg's *Confessions of a Justified Sinner* and Mary Shelley's *Frankenstein*, except that the touch is lighter. Fans of body horror will find more visceral lusciousness here than in most synthetic US nasties. One of Crispe's talents is the ability to call up synaesthesia: the mixture of sense impressions. I liked the comparison of beef to brass in music and to "the sexual potency of young men before it had been squandered".

Orlando Crispe's gusto for copulating with carcasses retrieved from his restaurant's cold store, then serving them, is only rivalled by his heartfelt loathing for female flesh itself. Women are more fondly regarded by the chef as marinades for his masterpieces.'

Chris Savage King in The Independent –
Book of the Week Choice

'This is a comic novel that barely pauses for breath, as it traces how the demonic Orlando Crispe develops from a mother-fixated youth into his flesh-crazed adulthood. Food and sex play a large part in everything he does, with his tastes for both becoming inextricably interwoven in his disturbed personality. It dwells so efficiently on the fetid and repellant side of human nature that it's easier to feel a sense of disgust, rather than to admire the intelligence of the author who has assembled this portrait of corruption and excess. Despite the relentless energy of the writing an engaging philosophical and psychiatric subtext, the novel as a whole feels overcooked.'

Sean Coughlan in The Times

'Sin, sodomy and sirloin. Madsen's novels are driven by an overwhelming sense of decadence and corruption. His view of human nature in general and sex in particular is gloomy, relieved only by a strong line in humour. *Confessions of a Flesh-Eater*, set in the present day, follows the adventures of Orlando Crispe, who decides on a career in cookery. He opens two highly successful restaurants, one in London, then one in Rome, following his apprenticeship in the kitchens (and bed) of Master Egbert Swayne. Master Egbert, a monstrously fat old homosexual, is endowed with a lovely turn of phrase; this is his verdict on nouvelle cuisine:

"More fucking tomfoolery. Half a hamster's tit and two peas floating on a raspberry haemorrhage for thirty quid? God in Heaven! Do they take us for dizzards!"

Orlando is sensually attracted to meat (he has carnal know-
ledge of sides of beef in between servicing Master Egbert) and
develops his own philosophy which leads, logically, from
cooking animals to cooking people.'
 Eugene Bryne in Venue

'The pleasures of the flesh loom monstrously large in this
defiantly scurrilous feast of baroque bad taste. Several degrees
kinkier and queerer than its cult predecessor, *Memoirs of a
Gnostic Dwarf*, it details the culinary, erotic and homicidal
exploits of Orland Crispe; mother-fixated chef, philosopher
and cannibal. It was when he embarked on drooling fridge-
side sex with a carcass of meat dressed in his mother's lacy
underwear (the meat, that is) that I began to suspect he might
be more than a couple of wafers short of the full Communion.'
 Phil Baker in The Sunday Times

'. . . a passion for splendidly cooked meat gradually and
inexorably becomes a kind of erotic madness. Orlando Crispe
is a chef of such skill and creativity that the restaurant over
which he presides becomes justly famous. Moreover, he dis-
covers – through a mixture of natural genius and intuition –
that meat can somehow absorb certain energies, particularly
sexual, which are then imparted to those who eat it.

Not only is *Confessions of a Flesh-Eater* an entertainingly
gruesome account of the fetishising of meat, it is also a thought-
provoking philosophical reflection on the power of absorption
of all kinds. Hunger for food, however, is not the only appetite
of relevance here. Orlando is omnivorous in his sexual tastes –
male, female; living, dead – each permutation takes him towards
the fulfilment of the ultimate in sensuous experience, an
experience that – for Crispe – transcends morality, strays into
the world of spirituality, and becomes a taste of the divine self.'
 Sebastian Beaumont in Gay Times

£7.99 ISBN 1 873982 47 X 223 p B.Format

Memoirs of a Gnostic Dwarf – David Madsen

'A pungent historical fiction on a par with Patrick Suskind's *Perfume*.'
 The Independent on Sunday Summer Reading Selection

'David Madsen's first novel *Memoirs of a Gnostic Dwarf* opens with a stomach-turning description of the state of Pope Leo's backside. The narrator is a hunchbacked dwarf and it is his job to read aloud from St Augustine while salves and unguents are applied to the Papal posterior. Born of humble stock, and at one time the inmate of a freak show, the dwarf now moves in the highest circles of holy skulduggery and buggery. Madsen's book is essentially a romp, although an unusually erudite one, and his scatological and bloody look at the Renaissance is grotesque, fruity and filthy. The publisher has a special interest in decadence; they must be pleased with this glittering toad of a novel.'
 Phil Baker in The Sunday Times

'. . . witty, decadent and immensely enjoyable.'
 Gay Times Book of the Month

'There are books which, arriving at precisely the right moment, are like life-belts thrown to one when one is in danger of drowning. Such a book for me was *Memoirs of a Gnostic Dwarf*.'
 Francis King

'. . . its main attraction is the vivid tour it offers of Renaissance Italy. From the gutters of Trastevere, via a circus freakshow, all the way to the majestic halls of the Vatican, it always looks like the real thing. Every character, real or fictional, is pungently drawn, the crowds are as anarchic as a Bruegel painting and the author effortlessly cannons from heartbreaking tragedy to sharp wit, most of it of a bawdy or scatological nature. The whole thing mixes up its sex, vio-

lence, religion and art in a very pleasing, wholly credible manner.'
Eugene Byrne in Venue

'– a hugely enjoyable romp.'
Jeremy Beadle in Gay Times Books of the Year

'The most outrageous novel of the year was David Madsen's erudite and witty *Memoirs of a Gnostic Dwarf*. Unalloyed pleasure.'
Peter Burton in Gay Times Books of the Year

'this is a rigorous and at times horrifying read, with some-thing darker and deeper in store than the camp excess of the opening chapters.'
Suzi Feay in The Independent on Sunday

'Madsen's tale of how Peppe becomes the Pope's companion and is forced to choose between his master and his beliefs displays both erudition and a real storyteller's gift.'
Erika Wagner in The Times

'Madsen's narrative moves from hilarity to pathos with meticulous skill leaving the reader stunned and breathless. The evocation of Italy is wonderful with detailed descriptions ranging from political problems to Leo's sexual proclivities. The novel is so hard to place in any definite genre because it straddles so many; historical novel, mystery and erotica – it is simply unique.'
Steve Blackburn in The Crack

'not your conventional art-historical view of the Renaissance Pope Leo X, usually perceived as supercultivated, if worldly, patron of Raphael and Michelangelo. Here, he's kin to Robert Nye's earthy, lusty personae of Falstaff and Faust, with Rabelasian verve, both scatological and venereal. Strangely shards of gnostic thought emerge from the dwarf's swampish

mind. In any case, the narrative of this novel blisters along with a Blackadderish cunning.'
The Observer

'If you're into villainy, perversion, religious pomp, the inquisition, torture, freaks and a smattering of sex, guess what . . . this Gnostic Dwarf has got the lot. Not only that, but the writer weaves a bloody good tale into the proceedings as well.'
All Points North

'This is what historical novels should be like, rendering the transitory world views of the historical and fictional characters, as believable as their more intrinsic characteristics of hate, greed, love and loyalty. Forget Martin Bloody Amis, *Memoirs* will make you laugh, cry – it may even impart a little wisdom.'
David Kendall in Impact Magazine

'Some books make their way by stealth; a buzz develops, a cult is formed. Take *Memoirs of a Gnostic Dwarf*, published by Dedalus in 1995. The opening paragraphs paint an unforgettable picture of poor portly Leo having unguents applied to his suppurating anus after one too many buggerings from his catamite. Then comes the killer pay off line: "Leo is Pope, after all." You can't not read on after that. I took it on holiday and was transported to the Vatican of the Renaissance; Pepe, the heretical dwarf of the title, became more real than the amiable pair of windsurfers I'd taken with me.'
Suzi Feay in New Statesman & Society

'*Memoirs of a Gnostic Dwarf* was overwhelmingly the most popular choice of Gay Times reviewers in last year's Books of the Year. Reprinted now this outrageous tale of the Renaissance papacy, heretics, circus freaks and sex should be at the top of everyone's "must read" list.'
Jonathan Hales in Gay Times

£8.99 ISBN 1 873982 71 2 336p B.Format